W9-COF-599

STRUGGLE FOR JUSTICE

FOCUS ON AMERICAN HISTORY SERIES
THE DOLPH BRISCOE CENTER FOR AMERICAN HISTORY
UNIVERSITY OF TEXAS AT AUSTIN
DON CARLETON, EDITOR

Preface by
Don Carleton

STRUGGLE FOR JUSTICE

Four Decades of Civil Rights Photography

 DOLPH BRISCOE CENTER FOR AMERICAN HISTORY

UNIVERSITY OF TEXAS PRESS ⚡ AUSTIN

PREFACE

On August 30, 1956, R. C. Hickman arrived outside of the whites-only high school in Mansfield, Texas. A talented professional photographer on assignment for the NAACP, Hickman was there to cover the school's court-ordered integration. It was a dangerous assignment, not only because Hickman was black, but because any photographer tasked with documenting civil rights events faced the risk of violence.

As he approached the school, Hickman saw figures swinging from the playground trees—effigies of black students, mock-lynched by a white mob. Hickman worked quickly to capture the scene, but the mob soon spotted him. He was able to get back to his car and drive off, but some of the mob pursued him to Fort Worth, twenty miles away. The chase finally stopped after Hickman found himself in a familiar neighborhood, took a couple of swift turns, and laid low in the gated parking lot of a family friend's funeral home.

Hickman's fellow photojournalist Flip Schulke also appreciated the value of a fast getaway. He made a habit of renting Cadillacs while on assignment for *Ebony* and *Life*, having learned from experience that he needed a car that could outrun the old pickups of the Ku Klux Klan. Nevertheless, on several occasions he found himself choking in clouds of tear gas along with those protesting. The police often accosted Schulke or left him locked up in squad cars for hours so he couldn't file his photographs for media distribution.

Hickman and Schulke were tough. So was Charles Moore. A former Golden Gloves boxer, he knew a thing or two about ducking, weaving, and taking shots—how to place his hands within the reach of danger while keeping his body and head outside. From there he could wait for the right moment, and then—snap. Perhaps this fight training is what allowed him to use a short lens so effectively during his career as a photojournalist. While covering integration at the University of Mississippi at Oxford in 1962 he worked to capture the campus riot while having pieces of concrete hurled at him. The rioters also broke into his motel room later that evening and beat him up. "To people who were really bigoted, I was the worst enemy, a Southern boy working for *Life* magazine," recalled Moore in the early 1990s. "For all the journalists covering the civil rights story through the '60s, it was difficult, exhausting, and often very dangerous."

Like those who marched, protested, and organized for civil rights and social justice, photojournalists put themselves in great danger. The Briscoe Center for American History's exhibit, *Struggle for Justice: Four Decades of Civil Rights Photography*, was our way of honoring those photographers and celebrating their legacy. Displayed on the University of Texas at Austin campus between November 10, 2017, and June 21, 2018, *Struggle for Justice* featured more than a hundred photographs and documents, including some of the civil rights movement's most iconic images taken between the 1930s and 1970s. These images and documents were drawn

from thirty-four individual collections housed at the center, including twenty-two separate photographic archives, such as those of Hickman, Schulke, and Moore. Together the material, much of which had never been previously displayed to the public, walked visitors through much of the civil rights era—from Jim Crow to Black Power. Together they provided a unique teaching moment, a lesson both inspiring and challenging: that social progress is possible when one values it above personal comfort and safety.

* * *

Racial segregation dominated American culture from the founding of the nation through the first half of the twentieth century. Many states, especially in the South, systematically discriminated against black Americans in all areas of public life, including at the ballot box, in the classroom, and in the dining hall. This system of "separate but equal" was inherently false, a legal construct that relied on the violence of both the state and the mob to maintain it. Opposition to these injustices has a long and storied history. The modern civil rights movement came to prominence rapidly after World War II, coalescing around the demand to repeal apartheid-like Jim Crow laws and a vision of a just, multiracial society. The vast majority of civil rights organizations practiced assertive nonviolence to meet these goals. Nevertheless, opponents often met their activism with violence and intimidation. Photojournalists

captured these dangers—the heroism of the movement's leaders, marchers, and organizers as well as the brutishness of those who opposed them.

Some photojournalists, like Schulke, who went on to become Martin Luther King's personal photographer, embedded themselves in the struggle. For others, like Hickman, documenting the movement was simply part of their work covering local events. Either way, by capturing the state-sponsored violence meted out to civil rights activists, photojournalists placed themselves within range of the same dangers. For example, in February 1965, *Birmingham News* photographer James "Spider" Martin documented state troopers repressing protests in Marion, Alabama. After sneaking in to the local hospital (with the hope of continuing his report), a trooper confronted him. He ran away but was pursued down the corridors. A few turns later he had lost the trooper but was now lost himself. "A black clean up lady was mopping up and without speaking she opened a storage closet," recalled Martin in a document preserved in his archives at the center. The trooper then came around the corner and angrily questioned the custodian. Martin hid in silence trying not to choke on cleaning product fumes while the woman calmly stated she hadn't seen anyone. Eventually the trooper moved on. "You better leave," she said, after reopening the closet. "They done killed Jimmie Jackson and beat up on a white TV fella tonight." Martin was indebted to her quiet, workaday courage. A month later, he was covering the "Bloody Sunday" marches in Selma, Alabama.

The contrast between Martin and the hospital custodian (or indeed Hickman) was one Martin readily admitted. As he put it in another document, he was able to "fit in when and where it was necessary." Wearing a camera was provocative—"like wearing a bulls-eye"—but he could always "turn on the Southern charm. Sometimes it would help." Likewise, photojournalist Stephen Shames, the unofficial photographer of the Black Panthers for many years, understood how being white afforded him certain protections not afforded black photographers or activists. When covering the 1968 Democratic National Convention protests he was careful to keep his distance from the police. "The cops, like Nixon, considered the press to be the enemy," he recalled in an interview with the center in 2018. Shames managed to keep out of their way for the most part, but at one point—after walking down the wrong street— he was accosted by a Chicago officer. Expecting to be beaten up, Shames was eerily surprised. The officer simply warned him he was entering a rough black neighborhood. "It was nice to not get hit in the head, but that's privilege. We walk around and don't even realize it. We take it for granted."

Photographers like Martin and Shames were willing to put their privilege on the line to document the discrimination of others. By doing so they helped galvanize public support for the civil rights movement. Photography is how many Americans experienced the tumult of the movement at the time. Today we tend to associate these images with electronic screens. In the 1960s, however, they were experienced primarily through reading newspapers and news magazines. Images provoked, saddened, shocked, inspired, and appalled. Key to their power was their capacity to undermine the opponents of civil rights, revealing the violence and prejudice that lurked beneath a polite veneer of respectability. We see that in Charles Kelly's image (pages 138–139) of state troopers using tear gas to disperse civil rights marchers in Canton, Mississippi, in 1966. The image is uncannily layered—camera-wielding news media, rifle-wielding police, defiant marchers—amid plumes of tear gas. Aside from aesthetics, those layers tell us much about the relationship between the news media, the police, and the protesters. One documents another oppressing the other. It gives us insight into the civil rights movement's tactic of assertive nonviolence, which so effectively discredited the mobs and police forces that stood in the way of justice.

In partnership with those who marched, photographers and their photographs were agents of change. In August 1965, only months after Moore and Martin captured the brutality of Bloody Sunday, President Lyndon B. Johnson signed the Voting Rights Act into existence. Were photographs a necessary prerequisite to legislative progress? Martin Luther King certainly thought so. He told Martin: "We could have marched, we could have protested forever, but if it weren't for guys like you, it would have been for nothing. The whole world saw your pictures. That's why the Voting Rights Act was passed." Because of the bravery of marchers, organizers, protesters—and yes, photographers—American culture was fundamentally challenged and changed. Eventually, slowly, incompletely, progress was made.

* * *

The Briscoe Center for American History actively collects the archives of photojournalists and documentary photographers. Much of this material has spent the last forty to fifty years in storage units, garages, and attics. Having been acquired by the

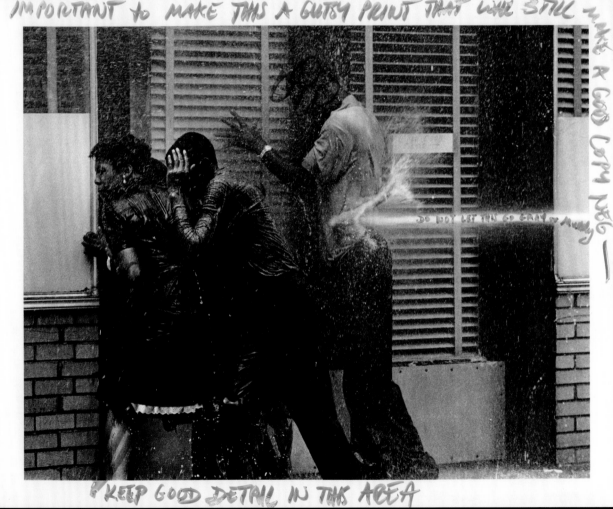

Charles Moore's printing instructions on his photograph of a protest in Birmingham, Alabama, in 1963. Charles L. Moore Photographic Archive.

center, they are now professionally preserved, open for research, and used in projects such as *Struggle for Justice*. Since the 1990s those collections have grown to include the archives of more than forty outstanding American photographers. They contain a wealth of visual history, but their value is not simply aesthetic. Photographs can contain a wealth of historical evidence—that is, they don't simply illustrate the points historians make in their research—they can support or even add to those points.

Photographs can be as important as documents, letters, and other texts for reconstructing the past. Like texts, they can be read. They do record the past incompletely, but if used critically and in corroboration with other sources, they can be a valuable primary source. In the case of the photographs included in this book, they can represent a body of visual evidence that documents the struggles, flashpoints, and achievements of the civil rights movement.

For those reasons the center collects entire photographic archives including negatives, color transparencies, contact sheets, ephemera, correspondence, and business records, as well as work and vintage prints, all of which provide the supporting material that made our exhibit possible. Perhaps the clearest example of this is Charles Moore's annotated work print of an image from 1963 (pages 112–113) that shows the gratuitous use of dogs and water hoses on peaceful protesters in Birmingham, Alabama. We see a young man pinned to a wall, sodden and exhausted, along with his fellow peaceful protesters. As a picture it is powerful, but Moore's annotations add distinct layers of historical value. Those annotations instruct the developer: "Make this a gutsy print that will still make a good copy neg." Other annotations stress the need to "keep the detail" of strong faces and soaked clothing, to prevent the lash of the hose from getting "gray or muddy." Moore gives similar instructions on other archival work prints as well: keep as much detail as possible, burn in the highlights, avoid muddiness—but not at the expense of being "a good copy neg." In addition to representing

quality craftsmanship, Moore wanted these photographs to remain reproducible to allow them to be seen by as many people as possible. Another example would be Martin's negative rolls from Bloody Sunday (pages 108–109). These unpublished images convey a sense of Martin's movement—looking one way to photograph, then running around to a different angle before taking others. We also get a feel for the chaos that the deployment of tear gas created at a protest.

I invite you to the Briscoe Center to come and experience these archives for yourself. *Struggle for Justice* is no longer on display, but the archives that made it possible remain accessible to researchers and students in the center's reading room. As impressive and inspiring as the exhibit was, the Briscoe Center's core mission is to make these materials available for research. My hope with this book is that you'll experience something of *Struggle for Justice* and be inspired to visit the center and experience these primary sources firsthand.

I hope you'll be inspired in another way as well. Peter Howe writes that iconic images are "produced under extraordinary circumstances but appeal to universal emotions. They touch a raw nerve in us." That's true of the images in this book. They are iconic in the true sense of the word—recognizable symbols that represent timeless human virtues and vices: courage, bravery, hatred, prejudice, patience, injustice, positive change. They are compelling, beautiful, disturbing, and encouraging—like the history they document. They remain salient and resonant, touching upon issues still with us. They conjure within us questions about the America we live in today as well as the one we've inherited. They remind us that those who fought for social justice moved forward with no guarantee that their efforts would be safe, successful, or appreciated. They speak not only to what America was, but what it is and what is can be.

Don Carleton
Executive Director
BRISCOE CENTER FOR AMERICAN HISTORY

INTRODUCTION

The history of American social justice movements is a major collection strength of the Briscoe Center. The center's growing resources include a wide range of materials related to the civil rights movement that provide both visual and documentary evidence of the organizations and individuals who worked for racial justice and equality, as well as their opponents.

This book highlights the perspective of photojournalists who covered the movement. Through photographs that document life in the Jim Crow era, portraits of the movement's leaders, and coverage of civil rights activism—as well as the violent resistance it often met—these images brought intimate eyewitness views of the struggle for civil rights to the public.

Selected from among the Briscoe Center's extensive photojournalism holdings, these images represent a visual record of the history of the movement between segregation and the beginnings of integration. The center's archival collections also provide insight into how the organizations functioned, including communications, fundraising, and legislative work. These materials provide diverse and in-depth resources spanning decades of this major movement in American history.

SEPARATE, UNEQUAL

Legally enforced racial segregation was pervasive in the South for the first half of the twentieth century. Sanctioned by the Supreme Court's "separate but equal" ruling in *Plessy v. Ferguson,* Southern states used segregation to systematically discriminate against black Americans in schools, public transportation, and other services, including entertainment facilities and restaurants.

These Jim Crow laws, in addition to voter suppression and the threat of both institutional and mob violence, meant that "separate but equal" was inherently false, often to a tragically farcical degree. As images in this section show, black Americans were treated like second-class citizens in their own nation. The Briscoe Center's extensive photojournalism archives provide a compelling witness to the unequal treatment and atmosphere of intimidation endured by black Americans between the end of Reconstruction and the advent of the post–World War II civil rights movement.

Clerk outside segregated store, circa 1959–1960

BRUCE ROBERTS
Bruce Roberts Photographic Archive

BROWN SISTERS

I n 1951, a group of Topeka parents filed a lawsuit on behalf of their children, all students at segregated schools. Among the students was Linda Brown, seen here at age ten with her sister Terry Lynn. Brown was refused admittance to the school near her home; instead, she had to walk through the Rock Island Switchyard to catch a bus to the all-black Monroe School.

The Supreme Court ruled on *Brown v. Board of Education* in May 1954, determining that "separate education facilities are inherently unequal" and violate the Fourteenth Amendment, which effectively ended legal public school segregation.

The Brown sisters walk to school, Topeka, Kansas, March 1953

CARL IWASAKI
Icons of American Photography Collection

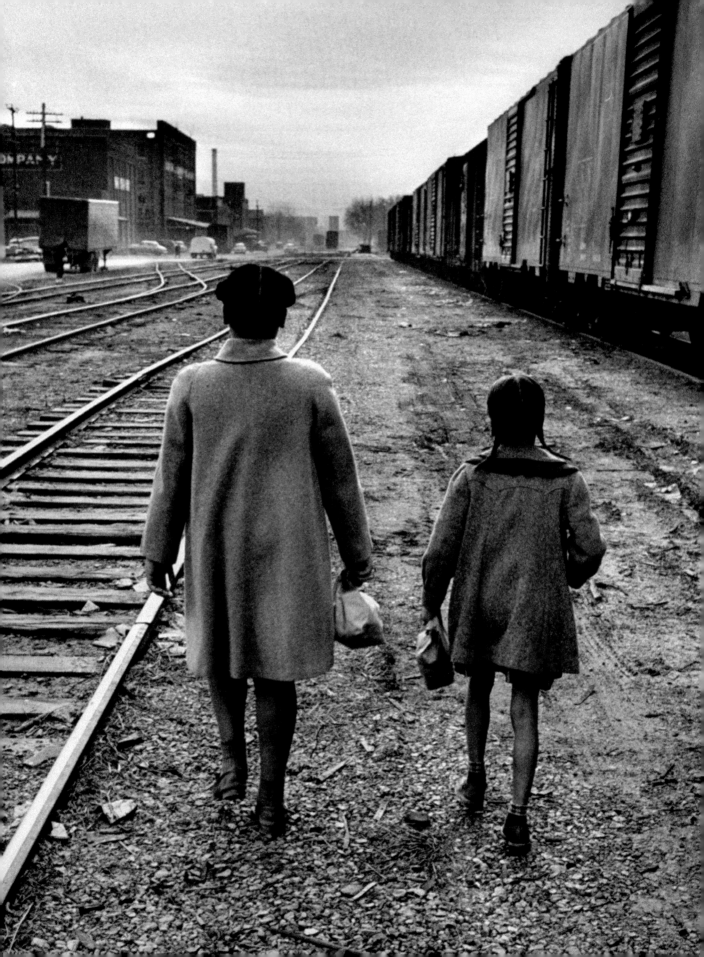

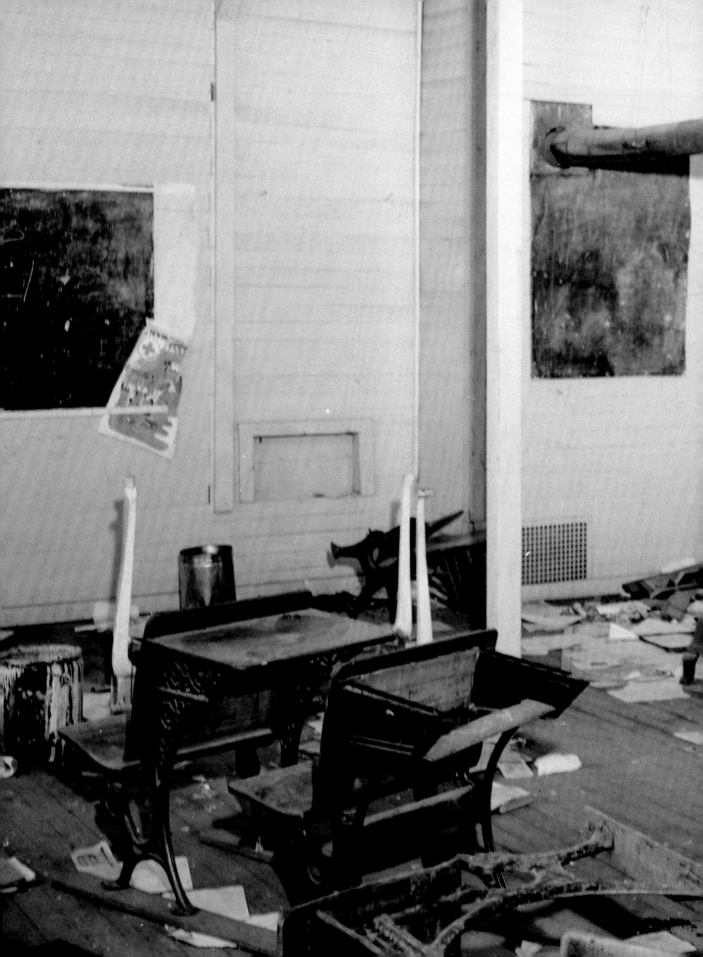

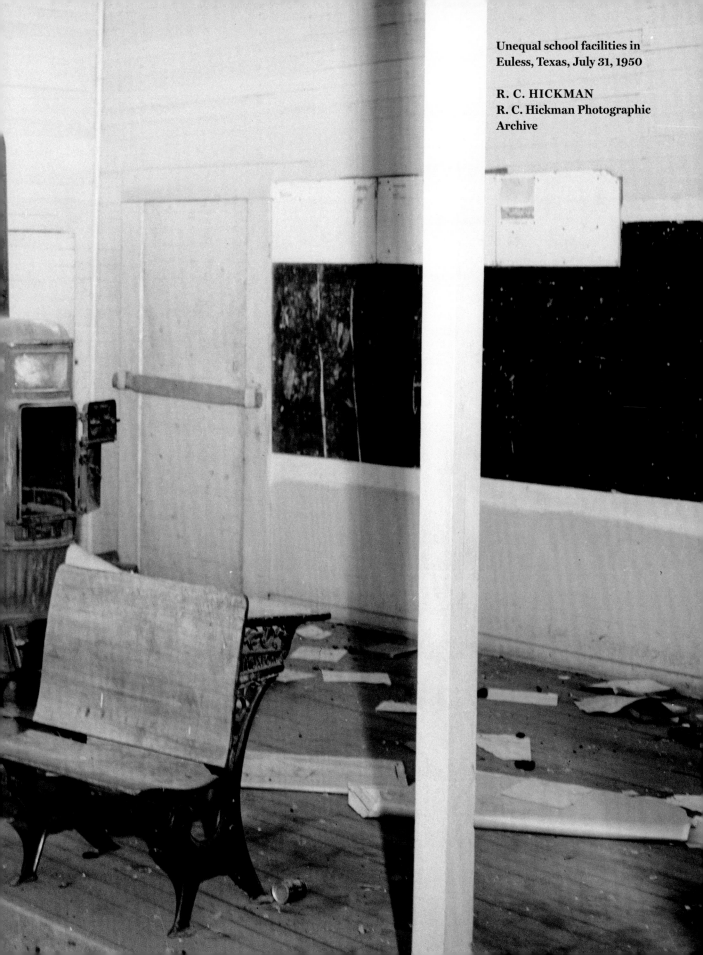

Unequal school facilities in
Euless, Texas, July 31, 1950

R. C. HICKMAN
R. C. Hickman Photographic
Archive

"Colored" city hall building in Italy, Texas, July 27, 1953

R. C. HICKMAN
R. C. Hickman Photographic Archive

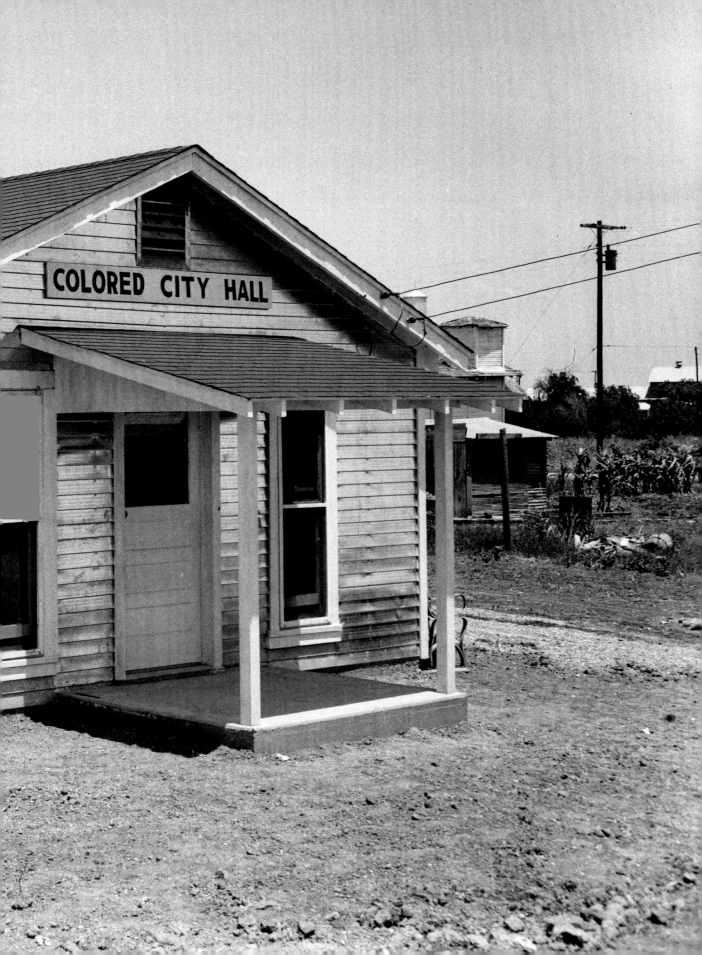

R. C. HICKMAN

In addition to working as a newspaper photographer, R. C. Hickman documented inequalities in public facilities around Dallas for the NAACP. After some of Hickman's photographs were used by the group in legal cases to prove racial discrimination in educational institutions, Hickman was called into court to testify that he had not altered his photographs or rearranged the subject matter to highlight disparities.

Marquee of the segregated Starlite Theater, Dallas, Texas, May 1953

R. C. HICKMAN
R. C. Hickman Photographic Archive

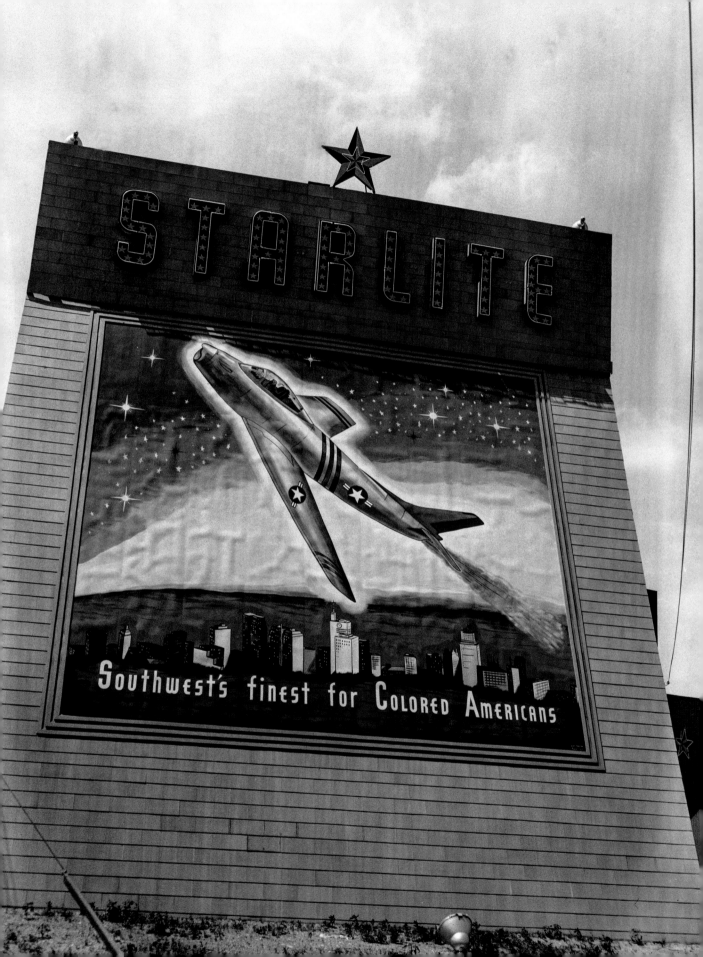

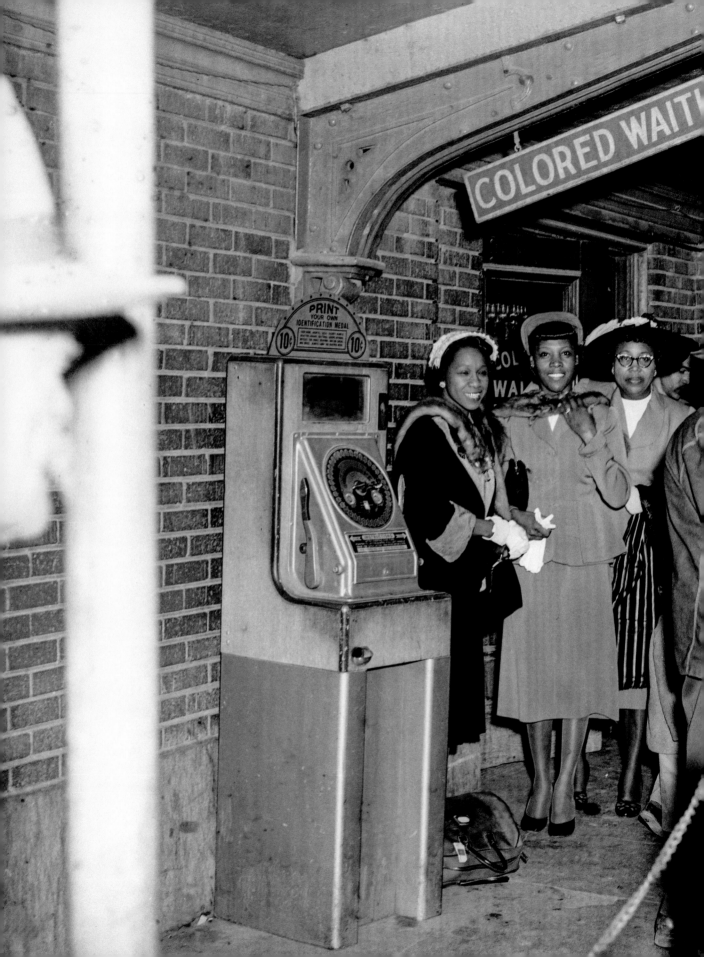

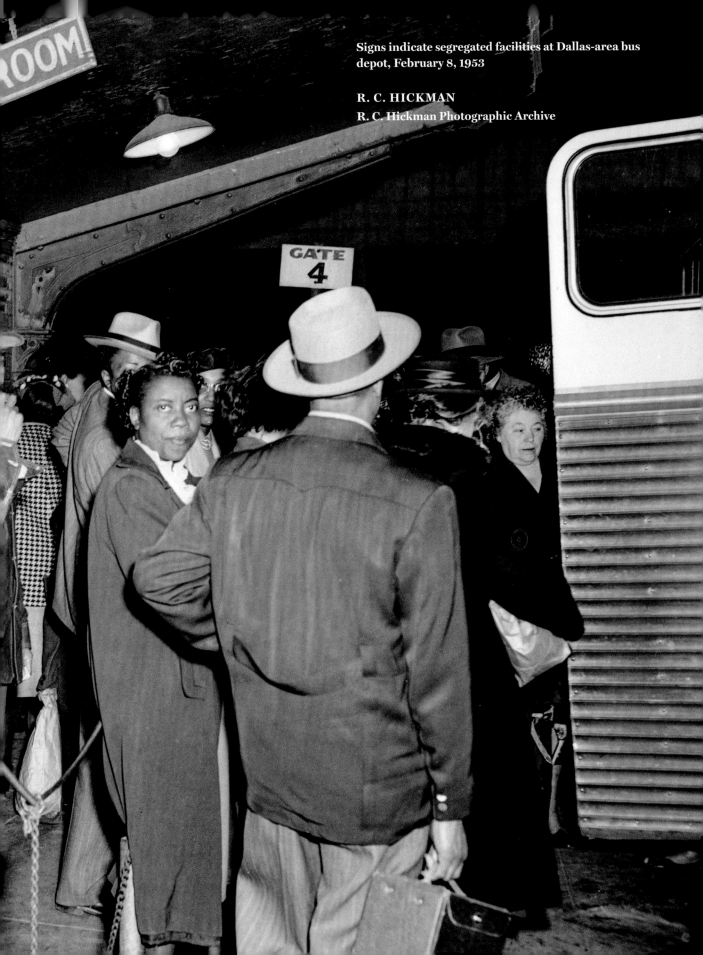

Signs indicate segregated facilities at Dallas-area bus depot, February 8, 1953

R. C. HICKMAN
R. C. Hickman Photographic Archive

Beginning in 1889 through the early 1950s, African Americans were only permitted to attend the Texas State Fair on "Colored People's Day," later known as "Negro Achievement Day." In 1953, the fair opened its doors to African Americans on all days, but access to the fair's attractions was limited.

To protest this inequality, Juanita Craft, then advisor to the NAACP Youth Council, organized a boycott of Negro Achievement Day in 1955. Teenaged members of the council marched along the day's parade route then formed a picket line at the fair's entrance. While the protest drew attention to the fair's discriminatory practices, it would be several more years before the fair was fully integrated.

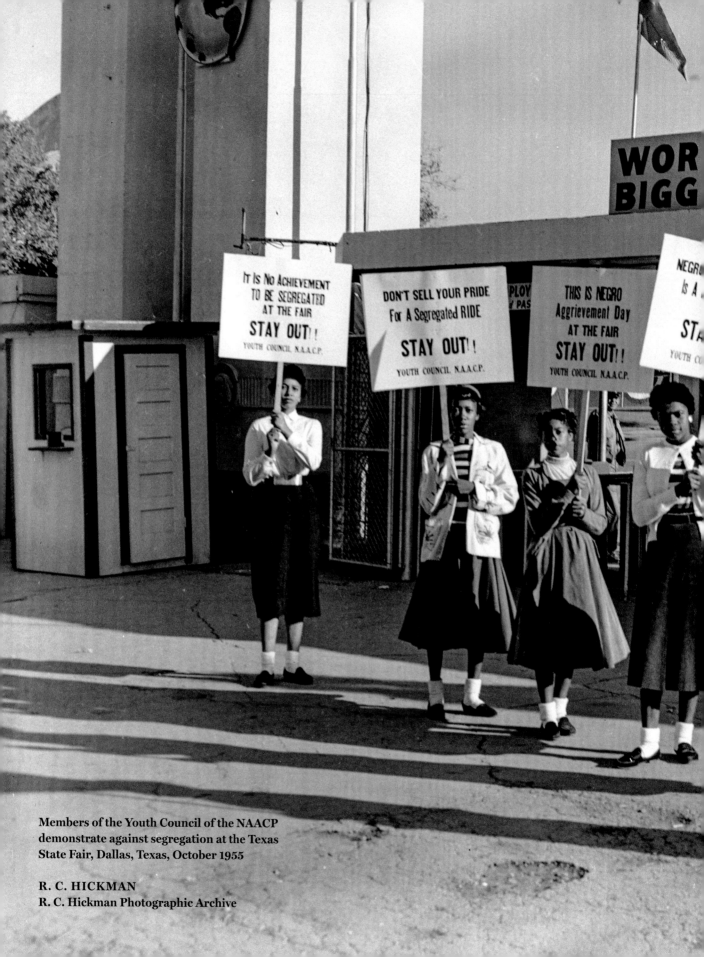

Members of the Youth Council of the NAACP
demonstrate against segregation at the Texas
State Fair, Dallas, Texas, October 1955

R. C. HICKMAN
R. C. Hickman Photographic Archive

GEORGE HUGHES

In May 1930, farmhand George Hughes was accused of raping a white woman. While Hughes awaited trial, rumors about the case began to spread, including false stories that Hughes had mutilated the woman and that she was not expected to live.

The day Hughes was transferred to the county courthouse, a large mob began to gather outside. The group turned violent, eventually starting a fire that suffocated Hughes inside a courthouse vault. Overnight, the mob retrieved Hughes's body, dragged it behind a car, and lynched it, then proceeded to burn down black businesses in Sherman, Texas, forcing the city's African American citizens into hiding.

Texas governor Dan Moody declared martial law the next day. While thirty-eight men and one woman were arrested in the wake of Hughes's death, only two were convicted—one for rioting and one for arson.

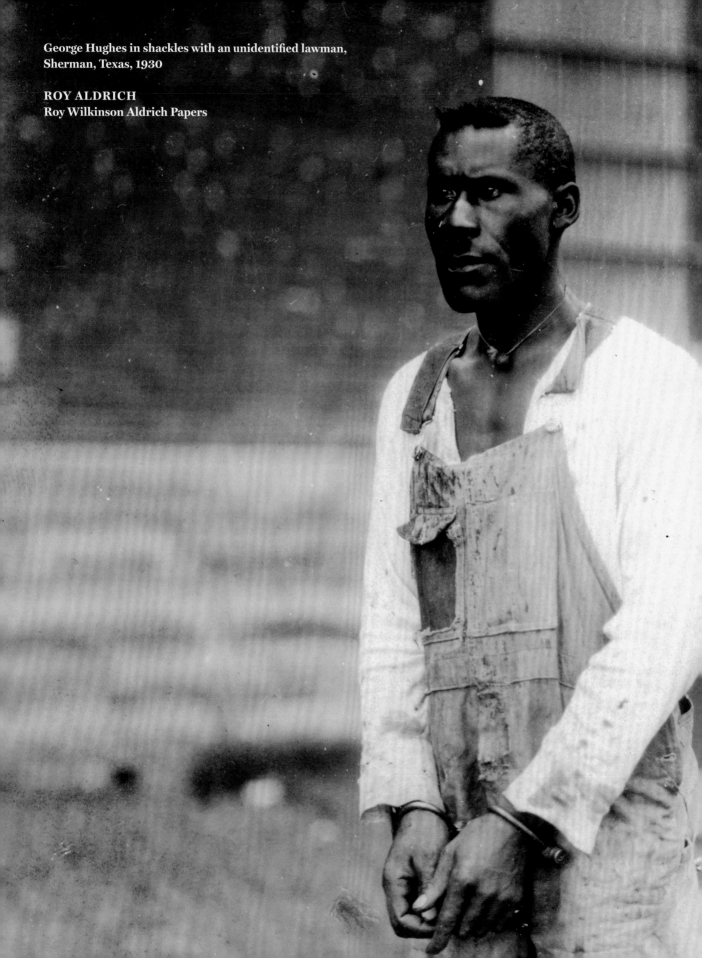

George Hughes in shackles with an unidentified lawman,
Sherman, Texas, 1930

ROY ALDRICH
Roy Wilkinson Aldrich Papers

LEADING THE STRUGGLE

The civil rights movement gained momentum rapidly after World War II, coalescing around shared desires to dismantle segregation by repealing Jim Crow laws, the demand for voting rights, a philosophy of highly assertive nonviolent resistance, and the promise of an America where all citizens were treated equally regardless of race.

Organizations such as the National Association for the Advancement of Colored People (NAACP), the Southern Christian Leadership Conference (SCLC), the Congress of Racial Equality (CORE), and the Student Nonviolent Coordinating Committee (SNCC) were headed by leaders such as Thurgood Marshall, John Lewis, James Farmer, Julian Bond, and Dr. Martin Luther King Jr.

These leaders were generally able to put aside any personal or philosophical differences in order to work together for change. However, other leaders— including Malcolm X and later the Black Panther Party—had less patience for nonviolent methods, believing that black Americans were entitled to use any means necessary to defend themselves from systematic injustice. The Briscoe Center's collections provide multiple perspectives on approaches and tactics in the struggle for civil rights.

Dr. Martin Luther King Jr. leads a voting rights march to the Montgomery County courthouse with the Rev. S. L. Douglas and Ralph Abernathy, March 17, 1965.

The group was in Montgomery awaiting a ruling on the legality of the Selma to Montgomery march.

FLIP SCHULKE
Flip Schulke Photographic Archive

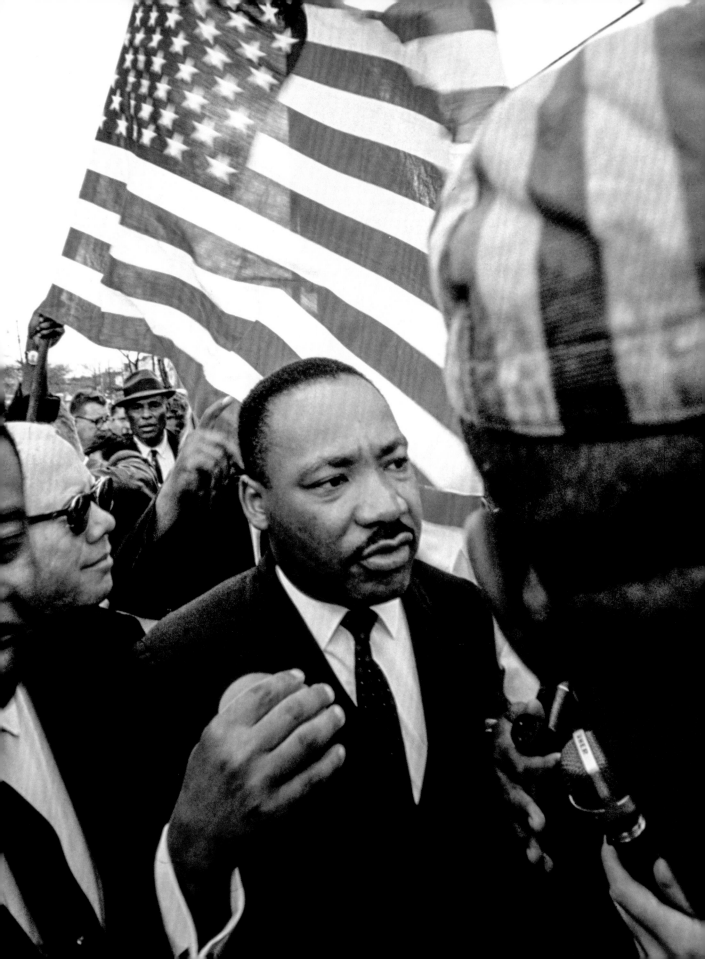

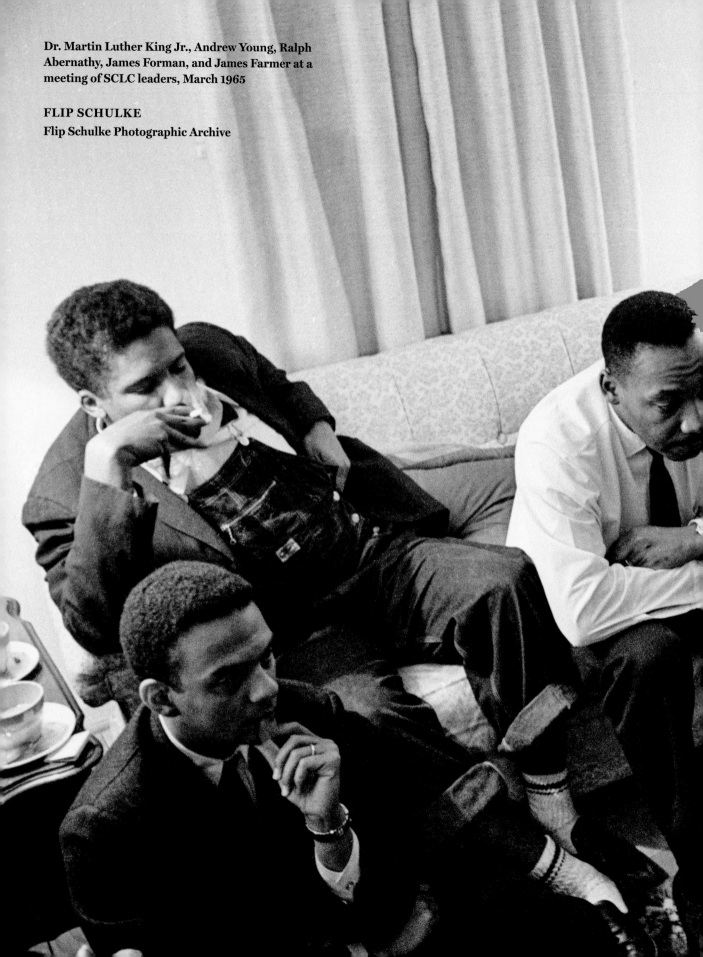

Dr. Martin Luther King Jr., Andrew Young, Ralph
Abernathy, James Forman, and James Farmer at a
meeting of SCLC leaders, March 1965

FLIP SCHULKE
Flip Schulke Photographic Archive

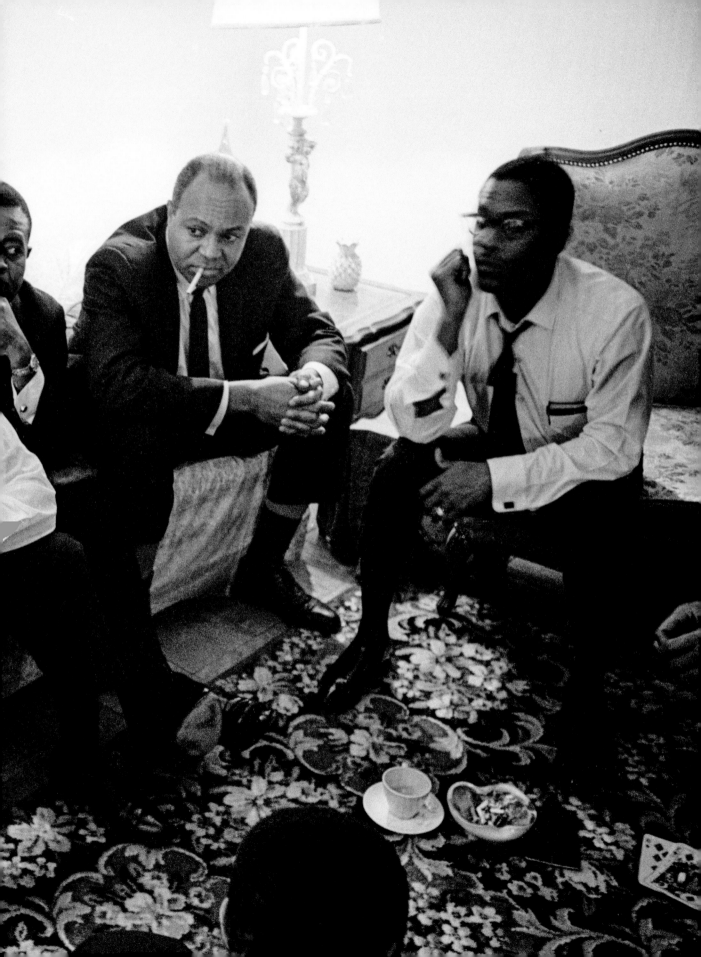

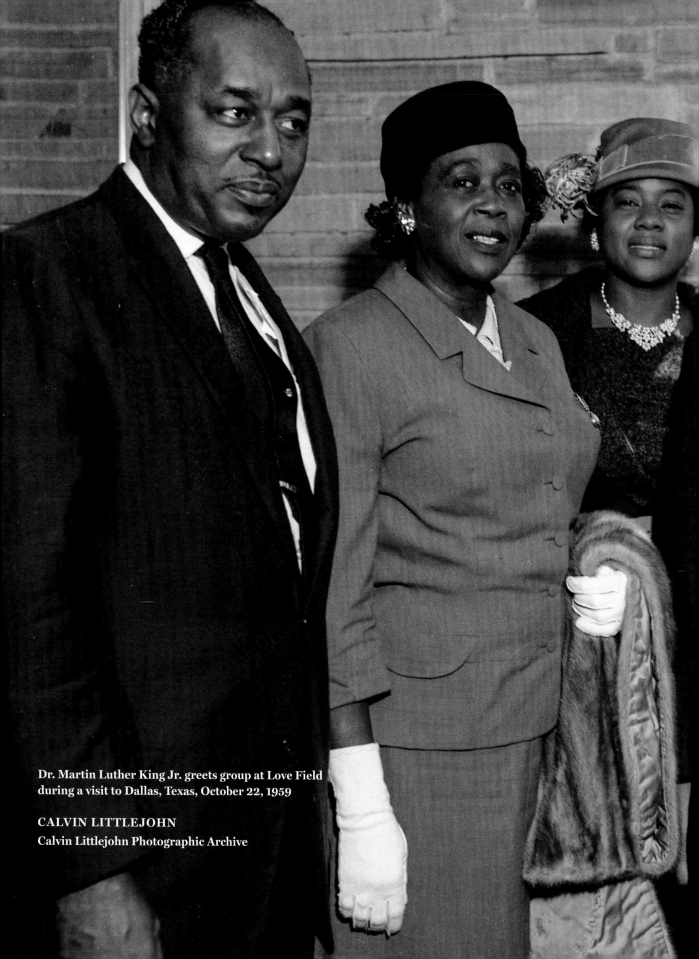

Dr. Martin Luther King Jr. greets group at Love Field during a visit to Dallas, Texas, October 22, 1959

CALVIN LITTLEJOHN
Calvin Littlejohn Photographic Archive

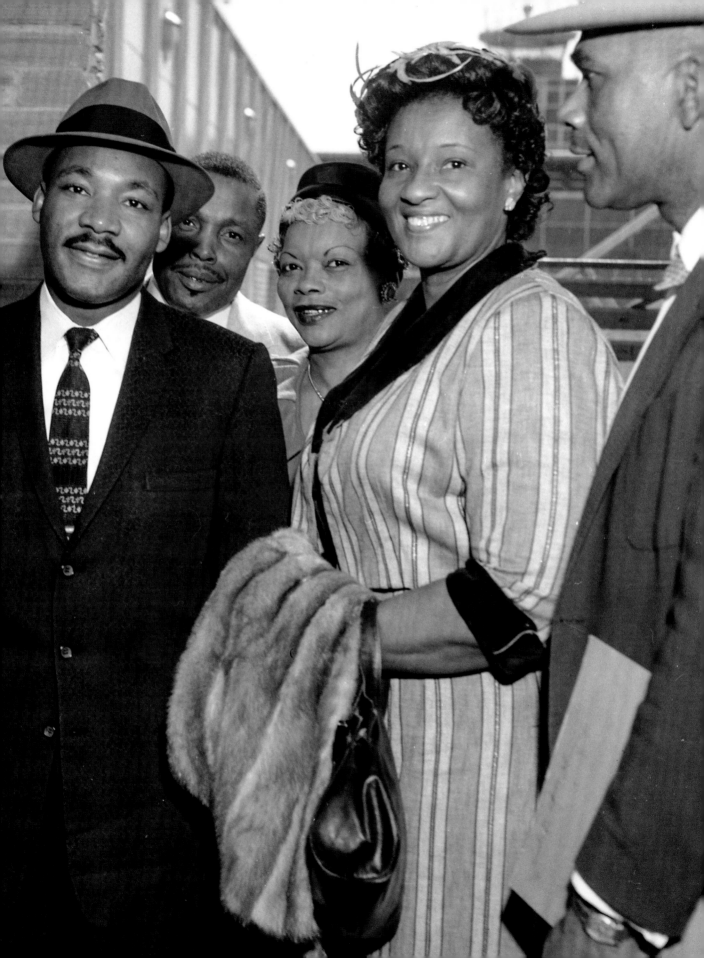

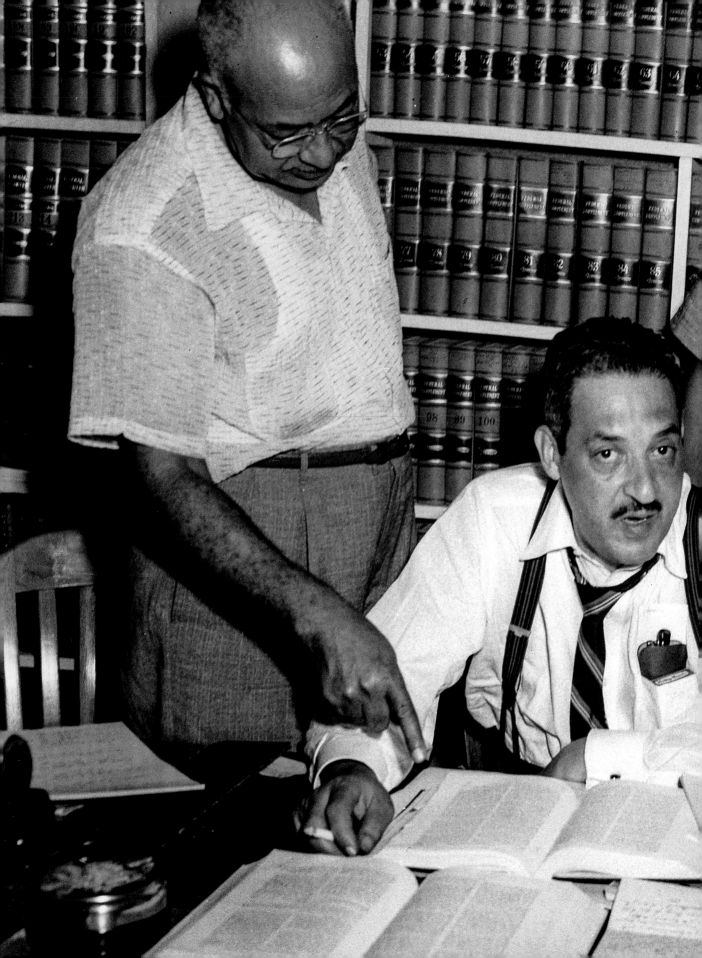

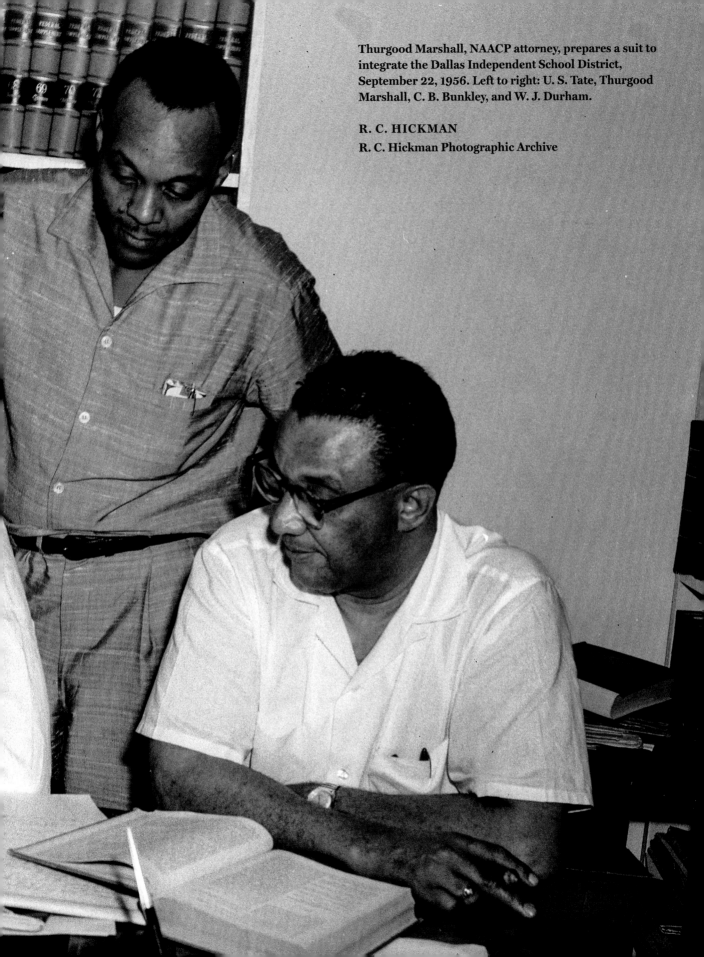

Thurgood Marshall, NAACP attorney, prepares a suit to integrate the Dallas Independent School District, September 22, 1956. Left to right: U. S. Tate, Thurgood Marshall, C. B. Bunkley, and W. J. Durham.

R. C. HICKMAN
R. C. Hickman Photographic Archive

Malcolm X in New York, 1964

EDDIE ADAMS
Eddie Adams Photographic Archive

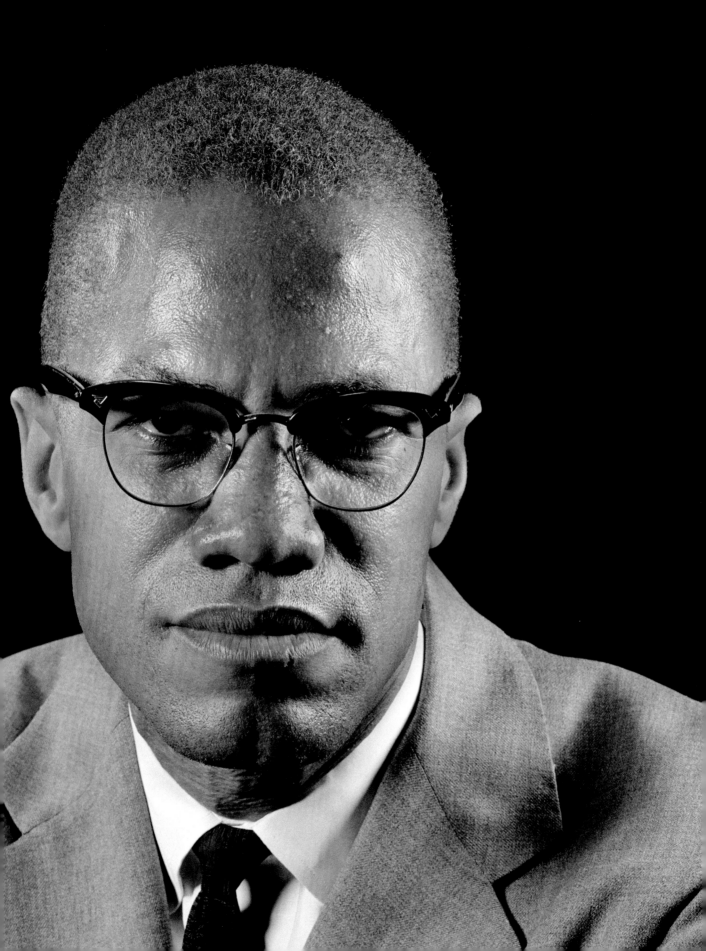

Miami's Hampton House Motel was one of few places in the city to offer accommodations to African Americans during the era of segregation; the local hotspot hosted renowned entertainers and sports greats in its lodgings, jazz club, and restaurant.

Bob Gomel's photograph shows Muhammad Ali at a pivotal point. He had just defeated Sonny Liston to claim the world heavyweight title, a victory that gave him the confidence to announce his conversion to Islam and renounce his "slave name," Cassius Clay. Malcolm X was instrumental to Ali's religious conversion, but the two men soon experienced a rift in their friendship due to Malcolm X's break with Nation of Islam leader Elijah Muhammad.

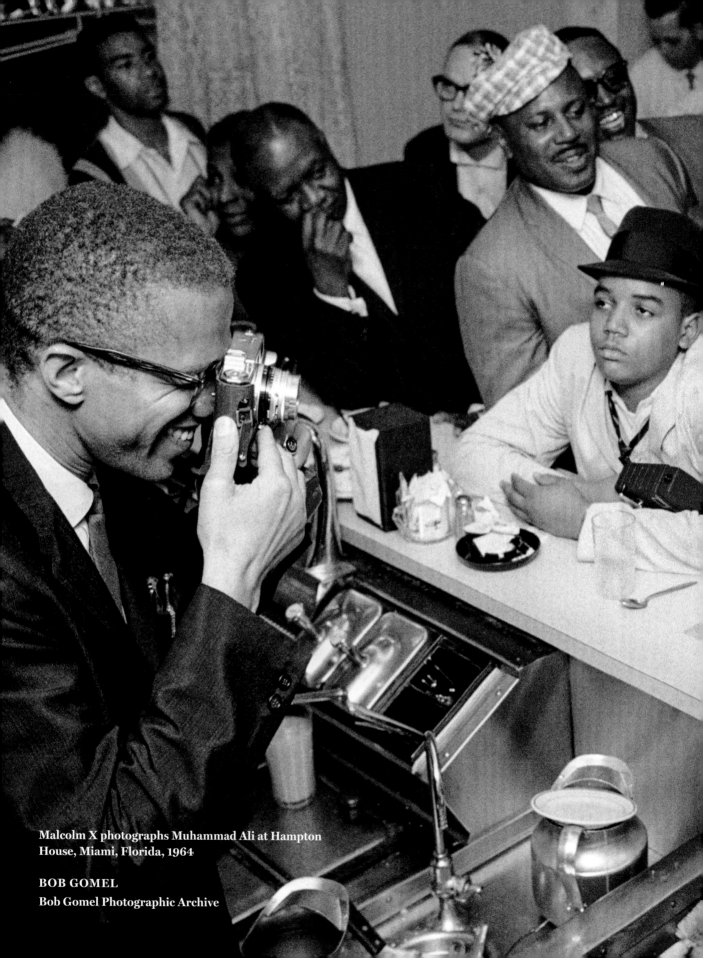

Malcolm X photographs Muhammad Ali at Hampton
House, Miami, Florida, 1964

BOB GOMEL
Bob Gomel Photographic Archive

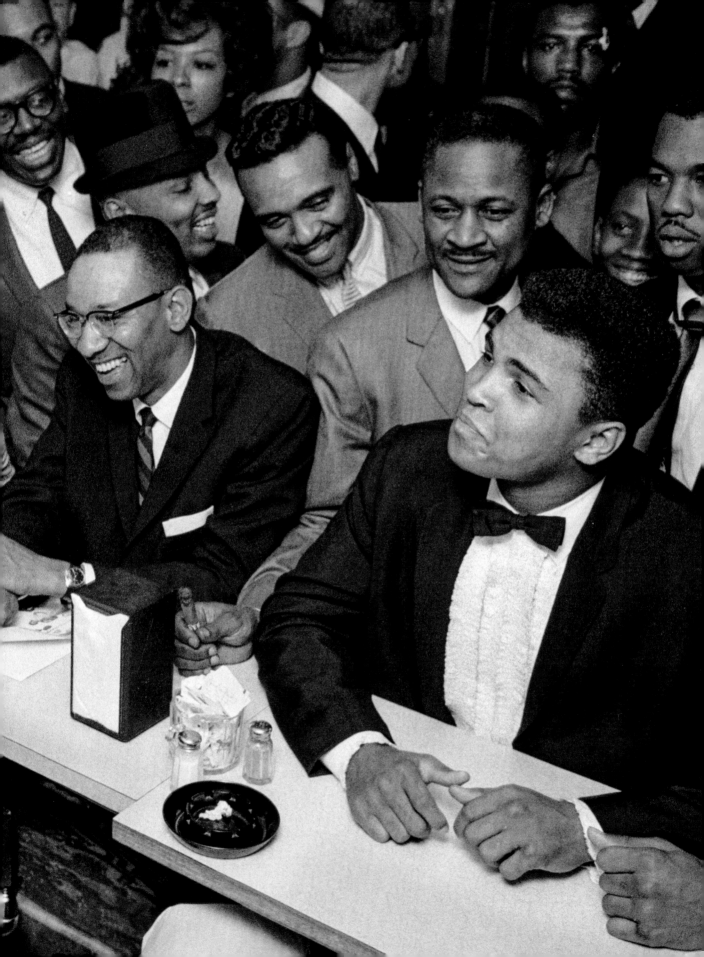

Although the Black Panther Party was founded in 1966 in Oakland, California, the panther symbol first came into use in rural Alabama, an area infamous for voter suppression and the subject of numerous voting rights campaigns.

As a part of his work with SNCC to register black voters and nominate African American candidates, Stokely Carmichael formed the Lowndes County Freedom Organization, the first group to use the panther symbol. Carmichael said the logo symbolized "the strength and dignity of black people, an animal that never strikes back until he's back so far into the wall, he's got nothing to do but spring out."

Voters complete ballots stamped with a Black Panther symbol during county sheriff elections in Greene County, Wilcox County, and Perry County, Alabama, August 1965

FLIP SCHULKE
Flip Schulke Photographic Archive

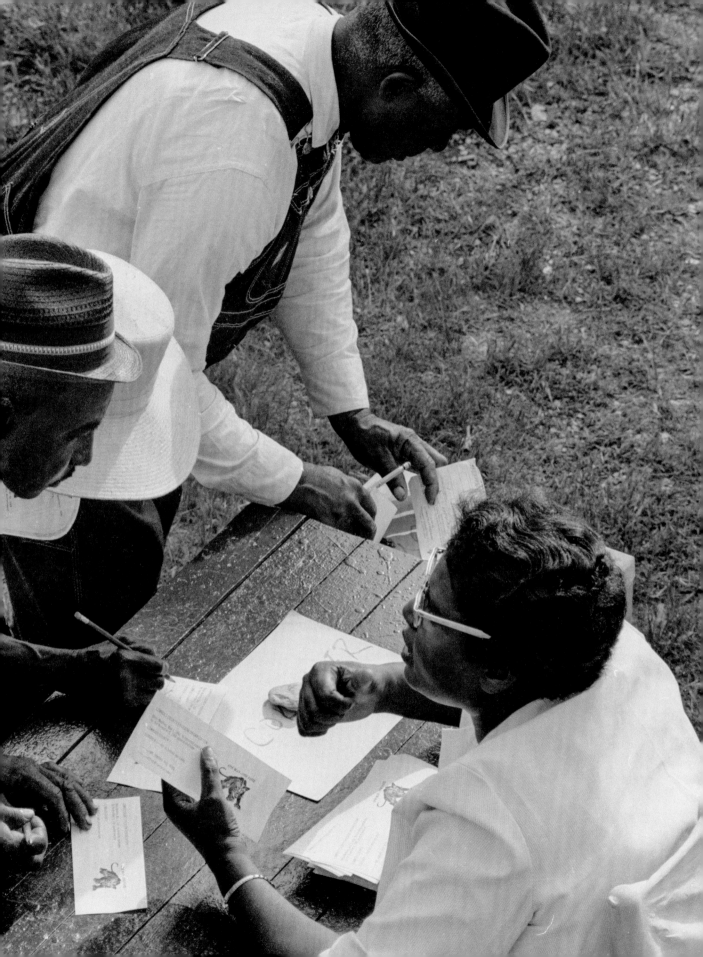

Huey P. Newton and Bobby Seale founded the Black Panther Party for Self-Defense on a ten-point platform and program outlining their demands for civil rights with an emphasis on the right of self-defense against racist attacks.

As a student at the University of California-Berkeley, Stephen Shames met Seale and Newton at an anti–Vietnam War gathering. Shames documented the Panthers' organization, members, and initiatives, and also supplied photographs for their weekly newspaper, the *Black Panther*.

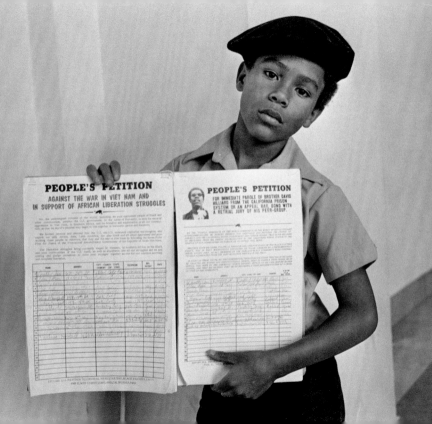

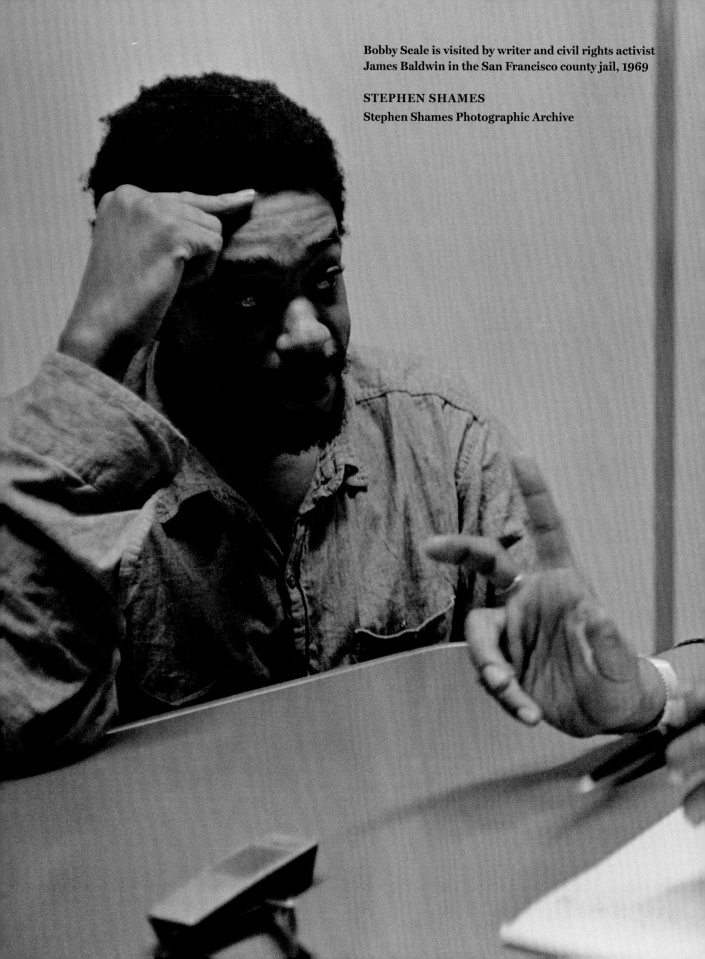

Bobby Seale is visited by writer and civil rights activist
James Baldwin in the San Francisco county jail, 1969

STEPHEN SHAMES
Stephen Shames Photographic Archive

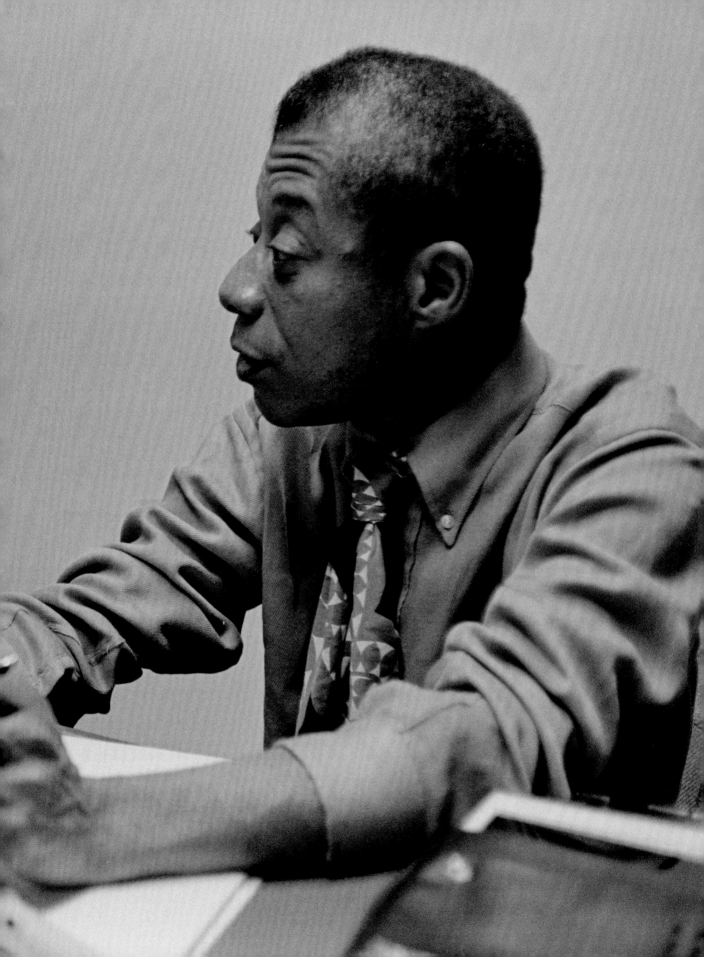

Black Panther Party member and activist George Jackson was shot and killed during an escape attempt from the maximum security San Quentin prison on August 21, 1971. Stephen Shames was the only photographer allowed inside the church during the funeral.

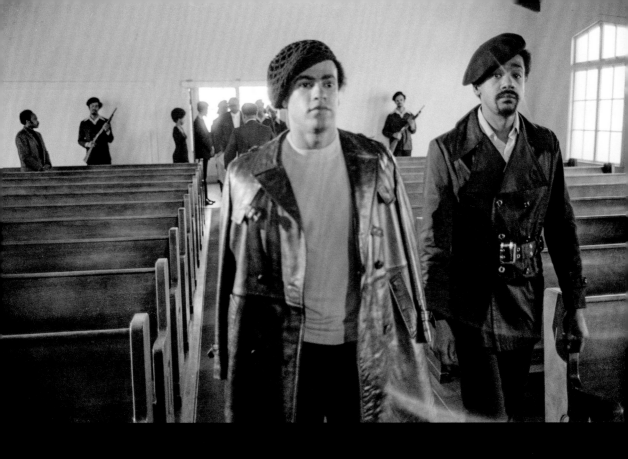

Huey P. Newton and Bobby Seale at George Jackson's funeral, Oakland, California, August 28, 1971

STEPHEN SHAMES
Stephen Shames Photographic Archive

COMMUNICATING AND COORDINATING

Central to the success of the civil rights movement, activist groups were often highly organized and effective communicators. Documents at the Briscoe Center detail how the message of the struggle was spread through meetings and printed outreach. They also help reveal the tactics and strategies behind direct action, as well as the personal experiences of those organizing at the movement's forefront.

Armband with black power symbol, circa 1960s

May 27, 1961, letter from James Farmer to his wife, Lula Peterson Farmer. James Farmer, co-founder of CORE, was one of the principal leaders of the 1960s civil rights movement. Farmer wrote this letter while jailed in Jackson, Mississippi, for testing the 1960 Supreme Court decision *Boynton v. Virginia*, in which the court struck down segregation in interstate travel. The historic "Freedom Rides" that Farmer launched in the South with twelve black and white colleagues in May 1961 reverberated throughout the growing civil rights movement.

Hinds County Jail
Jackson, Miss.
May 27, 1961
7 A.M.

Dearest Lula,

As you doubtless know by now, each of us was given 60 days (suspended) plus $200 (the time equivalent of which is 67 days). Most of us plan to appeal, but are not anxious to come out of jail in the meantime. We have 40 days in which to file the appeal. However Charlie thinks I will be needed in Wisconsin at the annual meeting, + prior to that to make preparations for it. Check with Charlie for details.

Last night, after the trial, we were transferred from the new city jail to the County Jail. I suppose we will go to work momentarily.

I'm sorry to leave you alone at a time like this. I hope your visit to Ewing was satisfactory. And I hope Eric (or Erica) is okay. Call on B8 Park for any help you need. I hate being away from you, but I know you agree that the fight is a right one! I've never been so confident of ultimate victory as I am now. "Delaying action" will delay us, but not stop us.

Tell Tami that Daddy is in jail for her sake, for he loves her. And I

Love you,
Jim

THE FREEDOM RIDERS

Ride Toward Freedom!

a clergyman's view

✳

an historian's view

Reprinted from The Amherst College Alumni News

CORE publication, n.d.

Farmer

OUR
STRUGGLE

the story

of

Montgomery

by Martin Luther King

Our Struggle: The Story of Montgomery,
by Martin Luther King, 1956.

LEGISLATING CHANGE

Congressional and political records housed at the Briscoe Center reveal the legislative aspects of the struggle for justice. The passage of civil rights legislation was complex, meandering, and controversial. Collection materials include bill reports and analyses, drafts and revisions of the legislative text, and letters to and from representatives regarding civil rights bills.

These records point to the workings of government, the diversity and impact of public opinion, and the nature of political communications. They also document how communities around the country accommodated—or resisted—civil rights legislation.

May 22, 1961, letter and press release from Attorney General Robert F. Kennedy. In this release, Kennedy describes attacks on Freedom Riders in Alabama and the federal government's actions both preceding and following those events.

Office of the Attorney General
Washington, D. C.

May 22, 1961

Honorable Sam Rayburn
House of Representatives
Washington 25, D. C.

Dear Congressman:

I am enclosing a copy of the telegram which I sent to Governor Patterson of Alabama on Saturday, May 20, informing him of the reasons why it was necessary to send United States deputy marshals to Montgomery to maintain peace and order and protect interstate travel and commerce.

The action was taken pursuant to Title 10, USC Section 333 which provides that:

"The President, by using the militia or the armed forces, or both or by any other means, shall take such measures as he considers necessary to suppress, in a State, any insurrection, domestic violence, unlawful combination "

Very sincerely yours,

Robert F. Kennedy

Robert F. Kennedy

"MARCHING FEET OF A DETERMINED PEOPLE"

Civil rights activism is amply documented in the center's photography holdings. Photojournalists and other photographers produced visual images that made it possible for millions of Americans to witness many different forms of activism. Large-scale demonstrations, such as the 1965 Selma to Montgomery march, became iconic moments in the movement, as did smaller protests including the Black Power salute by American athletes at the 1968 Mexico City Olympics.

Photojournalists often put themselves in danger to document the violent responses to civil rights activism, including police brutality and the intimidating, unsavory tone of counterprotests. This coverage helped to galvanize public support for some of the civil rights movement's key legislative goals.

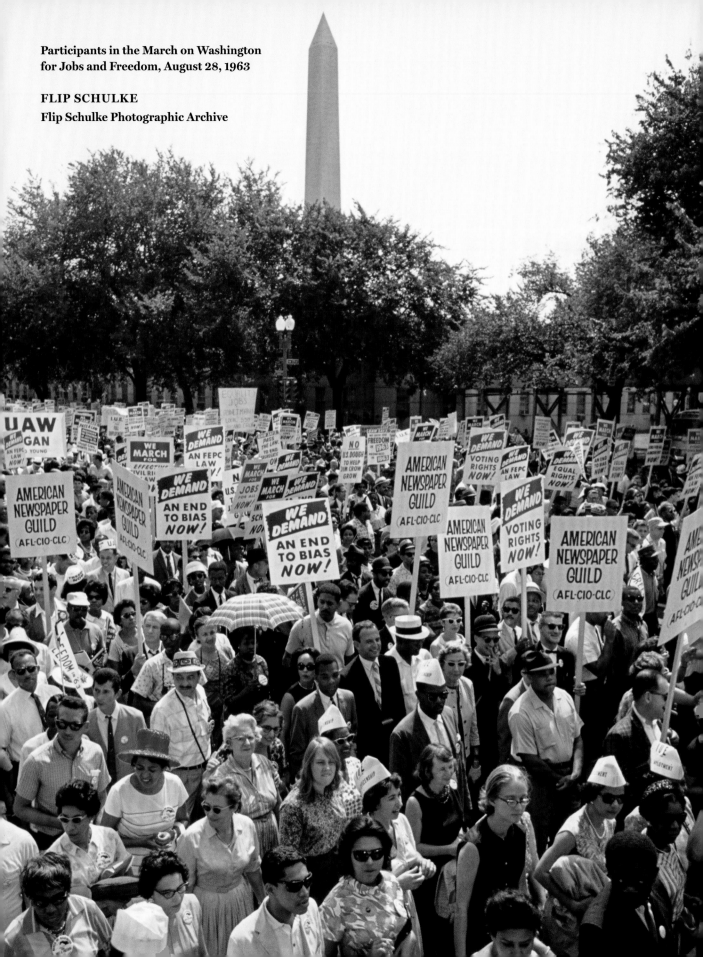

Participants in the March on Washington
for Jobs and Freedom, August 28, 1963

FLIP SCHULKE
Flip Schulke Photographic Archive

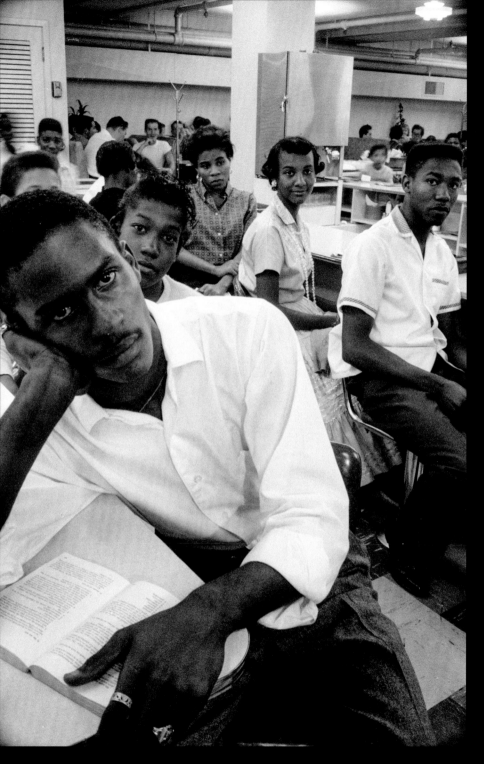

African American students wait to be served during a lunch counter sit-in at John A. Brown Luncheonette in Oklahoma City, Oklahoma, 1958

SHEL HERSHORN
Shel Hershorn Photographic Archive

Life photographer Paul Schutzer photographed Aaron and Dennis during a Freedom Ride to integrate the South's interstate bus system. A few weeks before, a ride led by James Farmer was firebombed outside of Anniston, Alabama, then abruptly came to a halt in Birmingham after a crowd attacked several riders. After the initial ride was cancelled, members of the New Orleans CORE chapter and the Nashville SNCC planned to continue the trip.

Despite an accompaniment of twelve National Guardsmen, seventeen highway patrol cars, three planes, and two helicopters, the group recognized their vulnerability to attacks. After safely arriving in Jackson, Mississippi, the riders were arrested and sentenced; Aaron spent four months in jail. Despite these arrests, the rides continued undeterred; over the summer of 1961, more than sixty Freedom Rides traveled across the South.

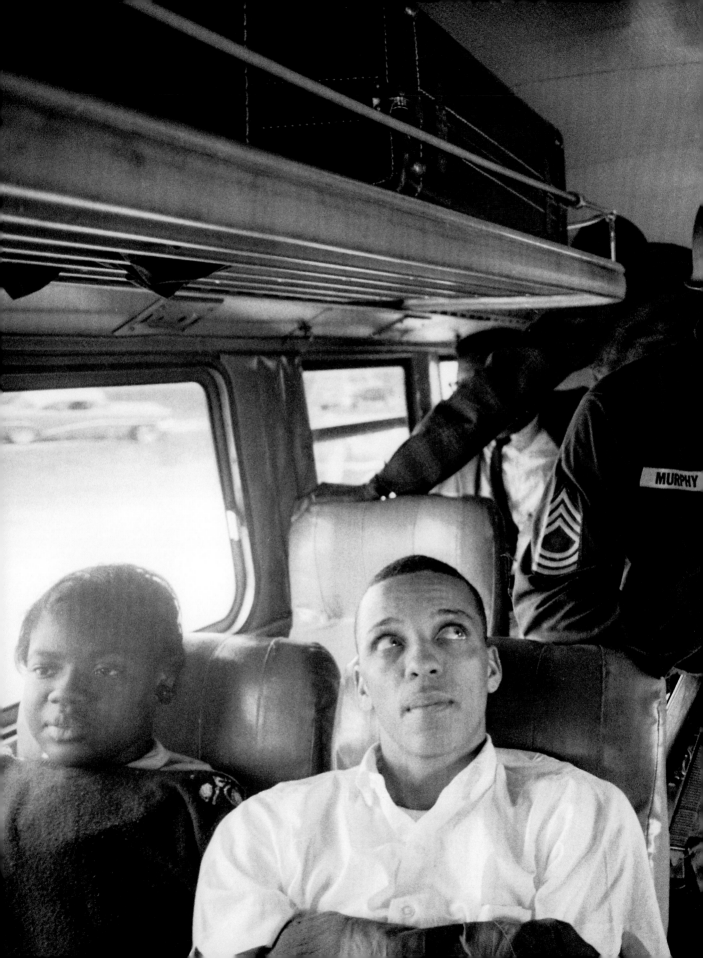

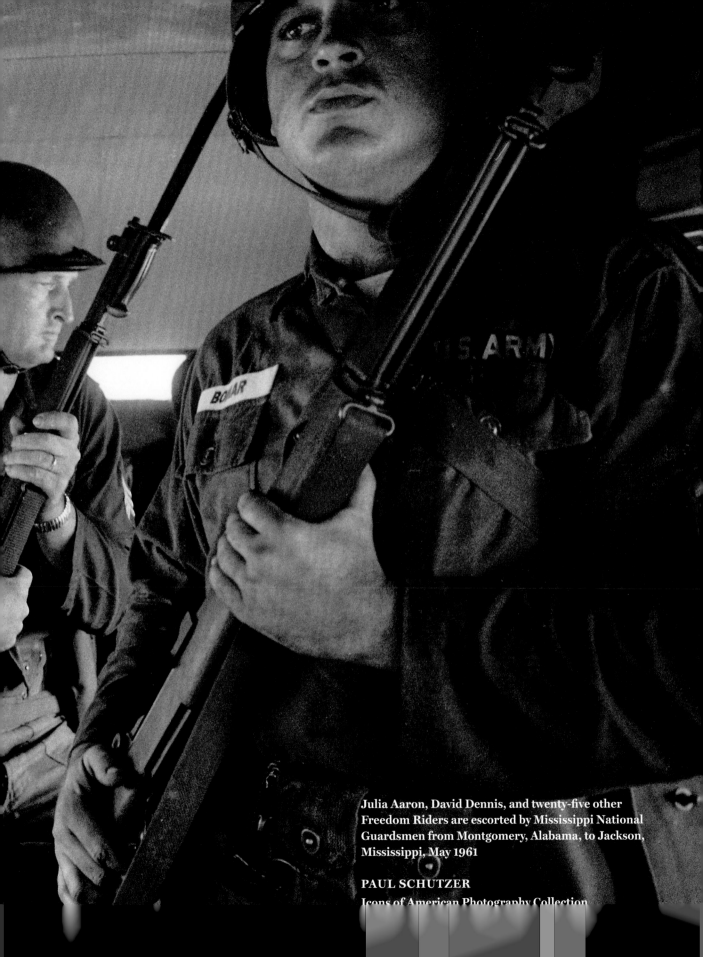

Julia Aaron, David Dennis, and twenty-five other Freedom Riders are escorted by Mississippi National Guardsmen from Montgomery, Alabama, to Jackson, Mississippi, May 1961

PAUL SCHUTZER
Icons of American Photography Collection

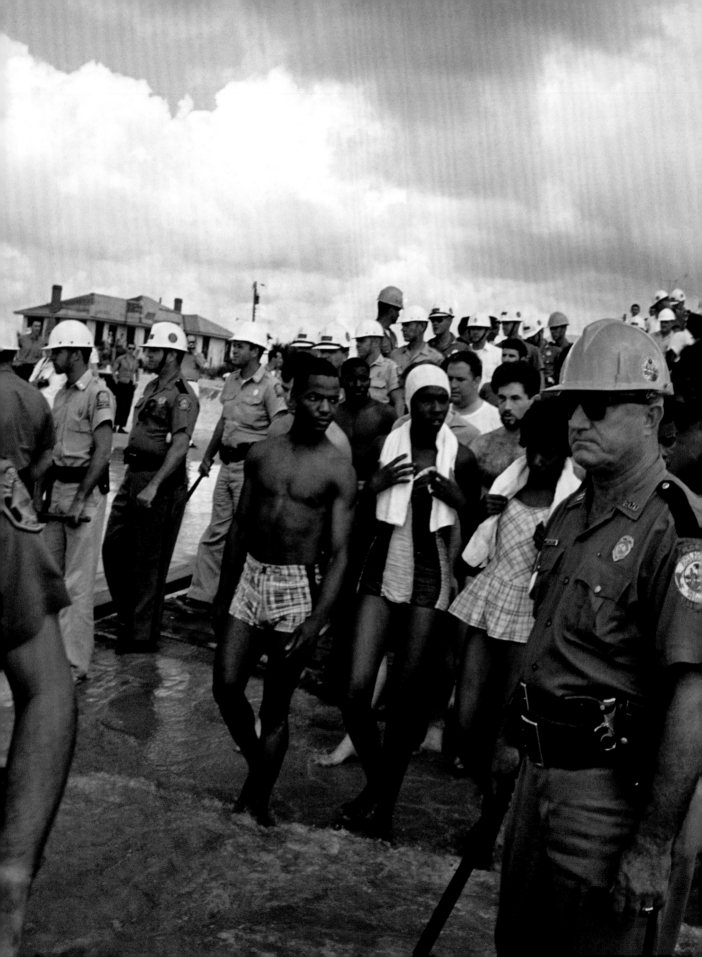

The spring and summer of 1964 witnessed an active civil rights campaign in St. Augustine, Florida, as protesters sought to integrate local swimming pools and beaches. That spring, local activist Dr. Robert Hayling called for widespread direct action, asking students from across the country to come to the city to protest its segregated facilities.

Some of the protests turned violent; several protesters nearly drowned during a swim-in at a local beach, and the manager of the Monson Motor Lodge, James Brock, poured hydrochloric acid into the motel's swimming pool to frighten demonstrators.

Protest wade-in at a beach in St. Augustine, Florida, June 1964

STAN WAYMAN
Stan Wayman Photographic Archive

American sprinters Tommie Smith (center) and John Carlos (right) give Black Power salutes as "The Star-Spangled Banner" plays at the 200-meter race medal ceremony at the Mexico City Olympic Games. The two runners employed multiple symbolic gestures to demonstrate solidarity with the civil rights movement; in addition to clenched fists representing Black Power, both removed their shoes to call attention to the pervasive poverty within the African American community. Carlos also carried beads to remember lynching victims and unzipped his jacket to demonstrate allegiance with American blue-collar workers. Similarly, Smith's black scarf represents black pride.

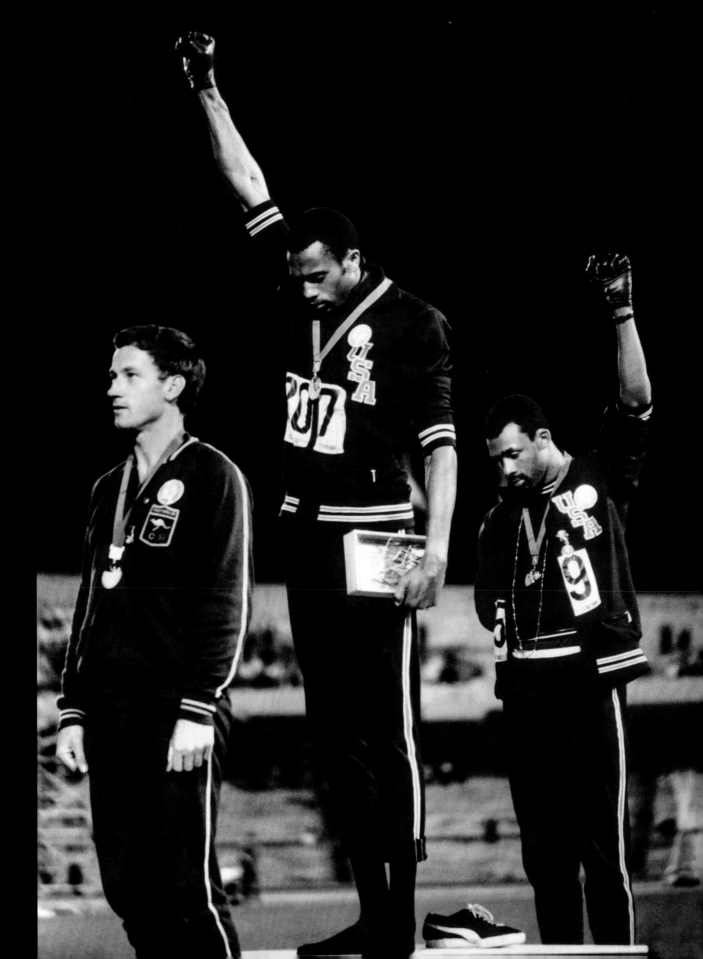

SELMA TO MONTGOMERY

The Rev. Hosea Williams, John Lewis, and other participants in the March for Voting Rights from Selma to Montgomery, Alabama, were confronted by Alabama state troopers just after crossing the Edmund Pettus Bridge outside Selma on Bloody Sunday, March 7, 1965. March participants were ordered to disperse, then were almost immediately attacked by state troopers with clubs and tear gas.

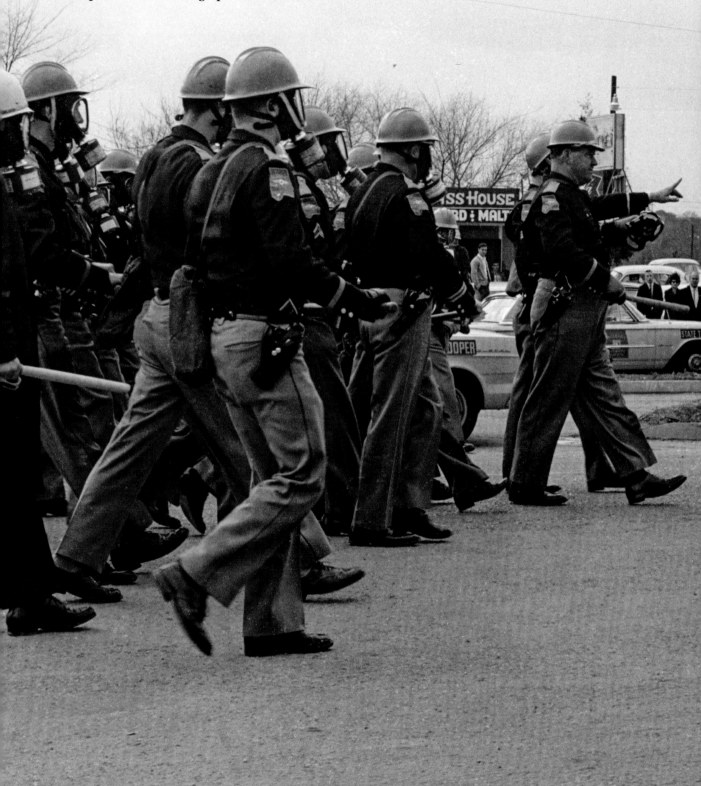

"Two Minute Warning." Bloody Sunday confrontation in Selma, Alabama, March 7, 1965

JAMES "SPIDER" MARTIN
James "Spider" Martin Photographic Archive

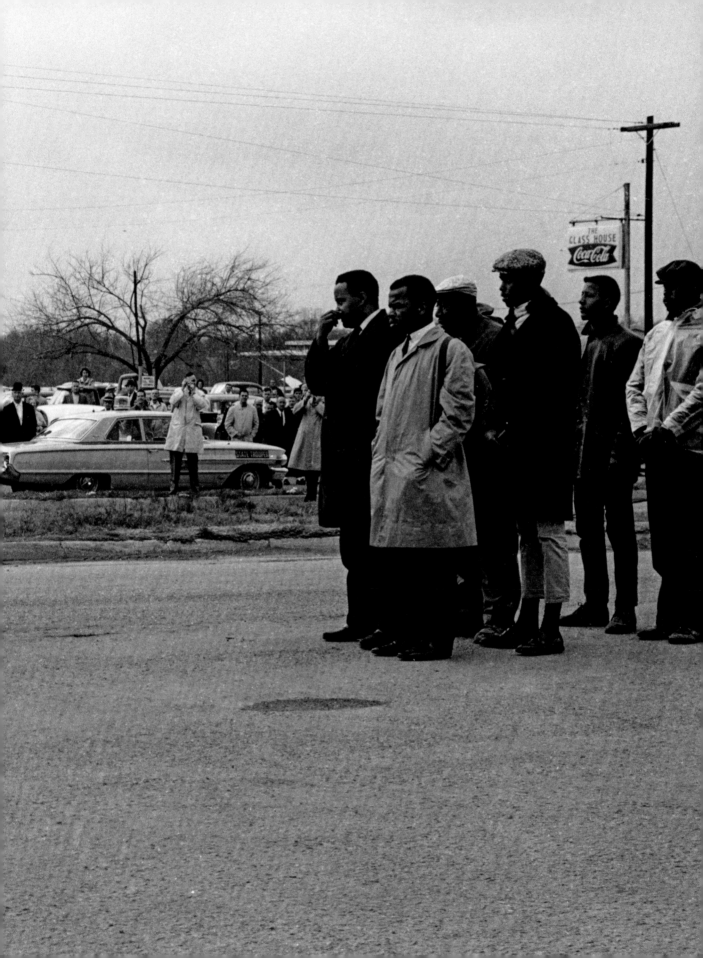

A civil rights marcher holds an American flag upside down as he joins thousands of other marchers in the Selma to Montgomery march, March 21–25, 1965. Two weeks earlier, the initial Selma to Montgomery march was violently stopped by Alabama state troopers as marchers left Selma, Alabama.

JAMES "SPIDER" MARTIN
James "Spider" Martin Photographic Archive

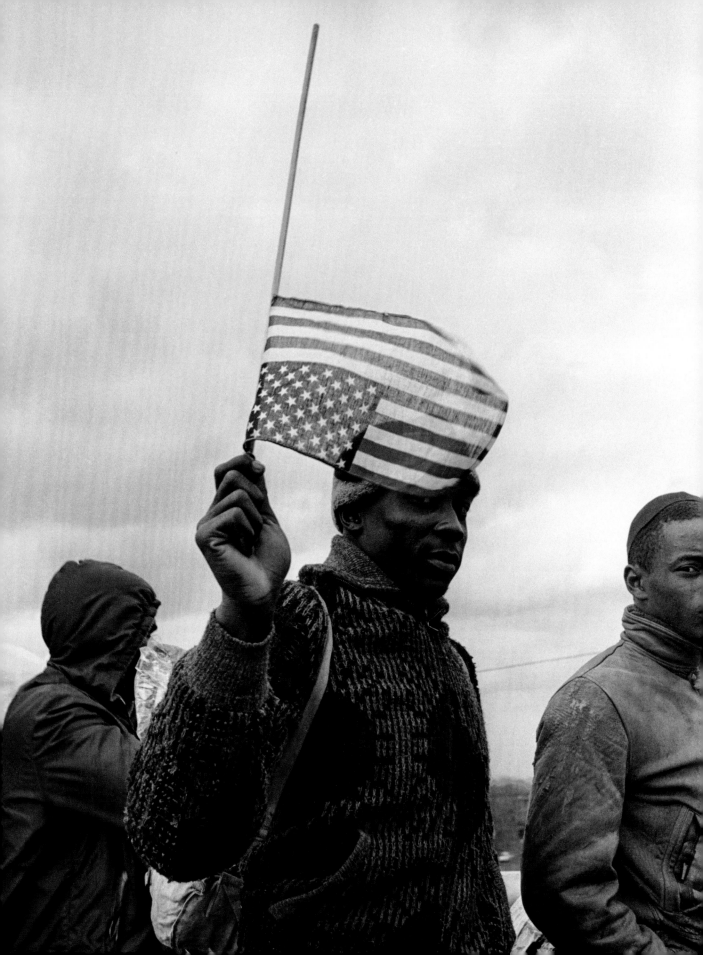

Counter-demonstrators in Montgomery, Alabama, carry signs protesting the marchers and President Lyndon B. Johnson, March 1965

JAMES "SPIDER" MARTIN
James "Spider" Martin Photographic Archive

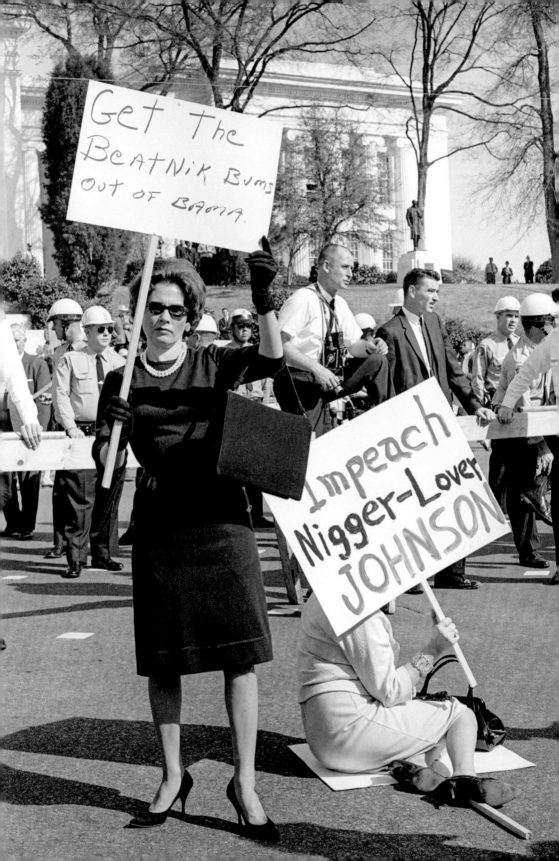

Participants in the Selma to Montgomery march,
March 1965

FLIP SCHULKE
Flip Schulke Photographic Archive

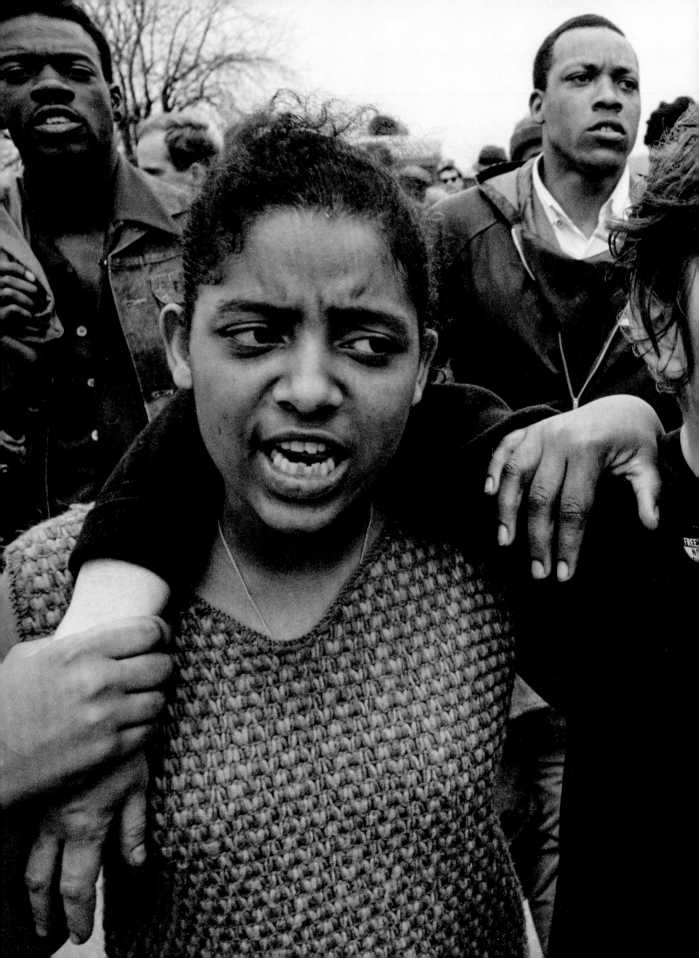

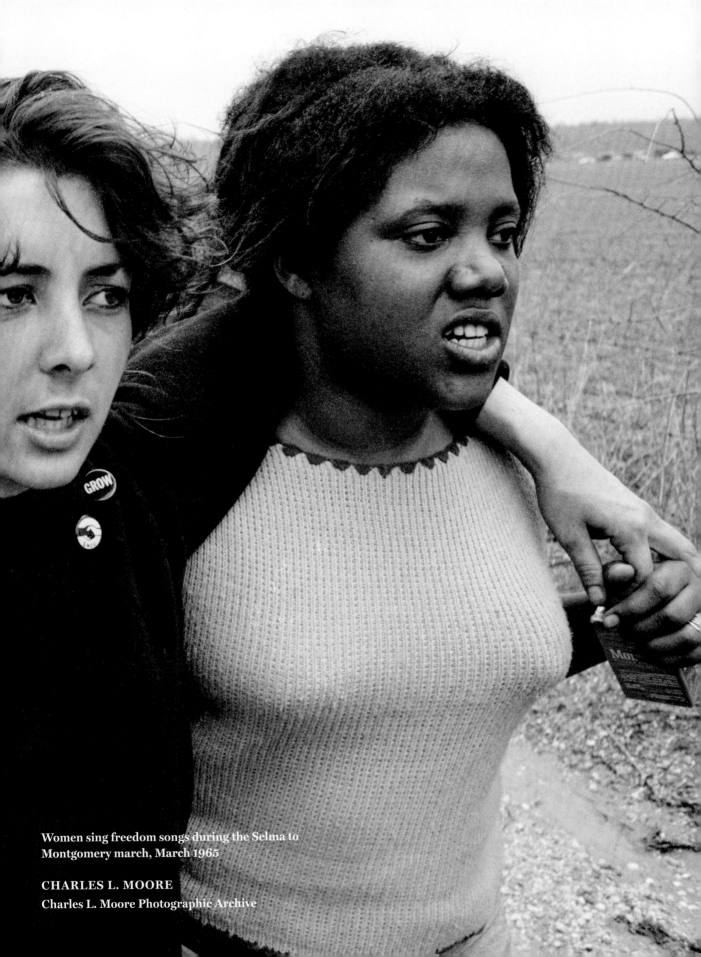

Women sing freedom songs during the Selma to
Montgomery march, March 1965

CHARLES L. MOORE

Charles L. Moore Photographic Archive

Dr. King traveled to Memphis in March 1968 to support the Memphis Sanitation Workers' Strike. The strike began that February after two workers, Echol Cole and Robert Walker, were crushed to death in the compactor of a truck as they attempted to escape a heavy thunderstorm. When the city offered their family members only a paltry settlement for the deaths, more than 1,300 workers walked off the job to protest for better pay and job safety. The strike's slogan, "I AM a Man," called for recognition of the humanity of the city's sanitation workers.

Four days after King's assassination in Memphis, Coretta Scott King led a 10,000-person march through the city to support the strikers and commemorate King; the march was followed by speeches by Mrs. King and Ralph Abernathy.

A young man listens to Ralph Abernathy speak in Memphis after the assassination of Dr. Martin Luther King Jr., April 8, 1968

DENNIS BRACK
Dennis Brack Photographic Archive

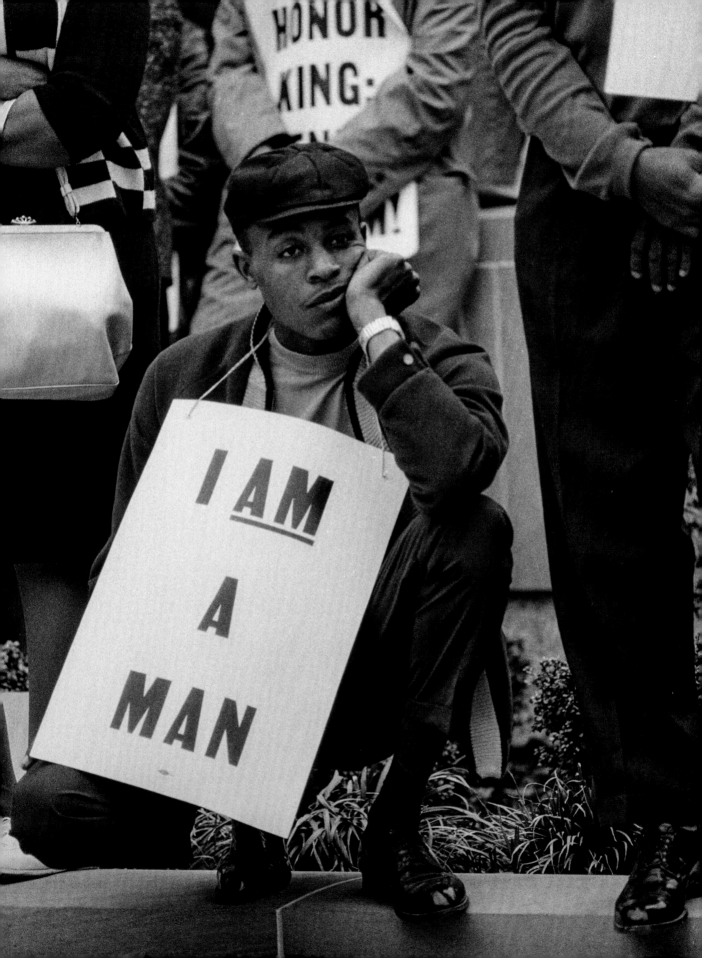

On September 10, 1963, President John F. Kennedy issued Executive Order 11118, which removed any "obstructions of justice" in the integration of Alabama's public schools. Despite a day of tense protests around the state, the president succeeded in enforcing a court ruling that ordered desegregation of the state's schools.

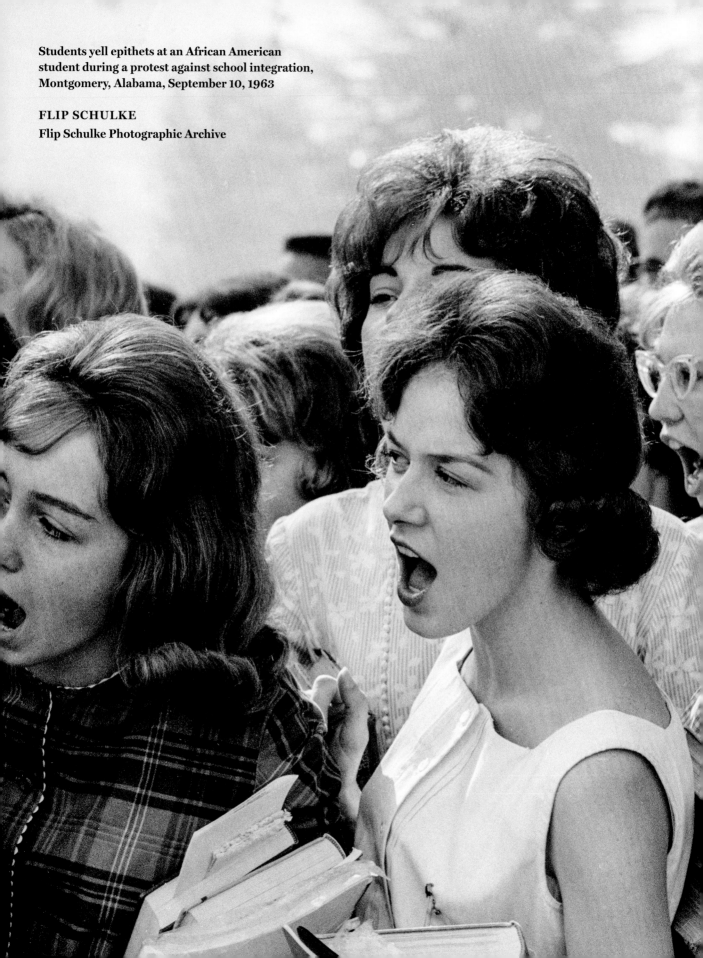

Students yell epithets at an African American student during a protest against school integration, Montgomery, Alabama, September 10, 1963

FLIP SCHULKE
Flip Schulke Photographic Archive

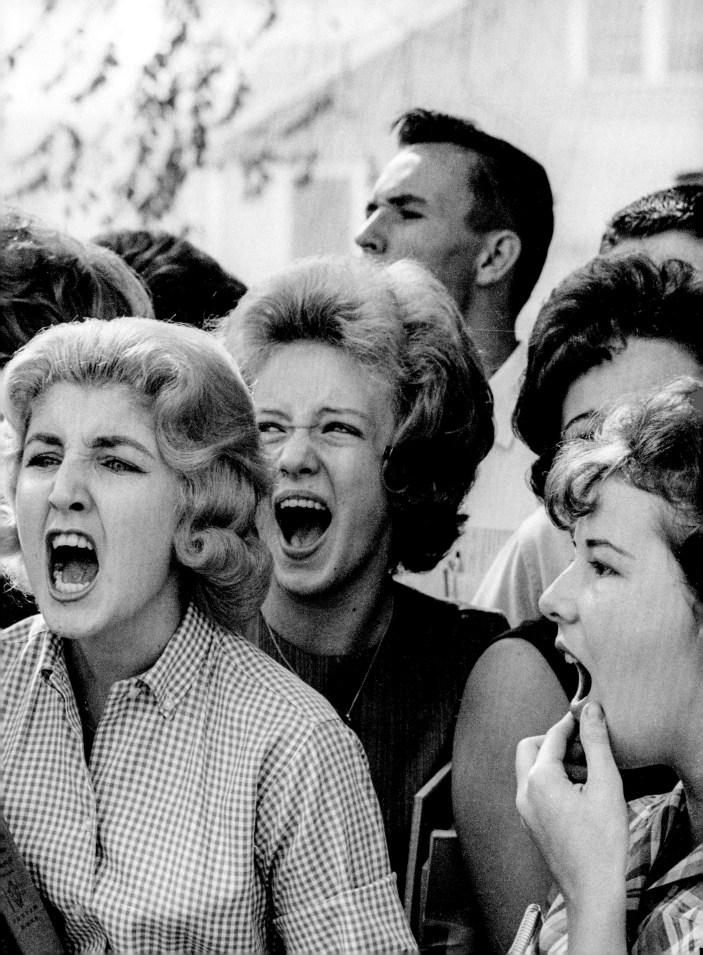

KU KLUX KLAN

Bob Jones played a key role in the public resurgence of the Ku Klux Klan in the early 1960s. In 1963, he received a charter from the United Klans of America to organize a chapter in North Carolina and became the state group's Grand Dragon.

Over the next several years, the group grew from a handful of members to 10,000, gaining enough strength that Klan members were able to gift Jones the Cadillac shown in the photograph; Jones proudly noted that no individuals were allowed to contribute more than 25 cents toward the purchase.

North Carolina Grand Dragon Bob Jones and an
unidentified Klansman prepare for a cross burning,
April 1965

BRUCE ROBERTS
Bruce Roberts Photographic Archive

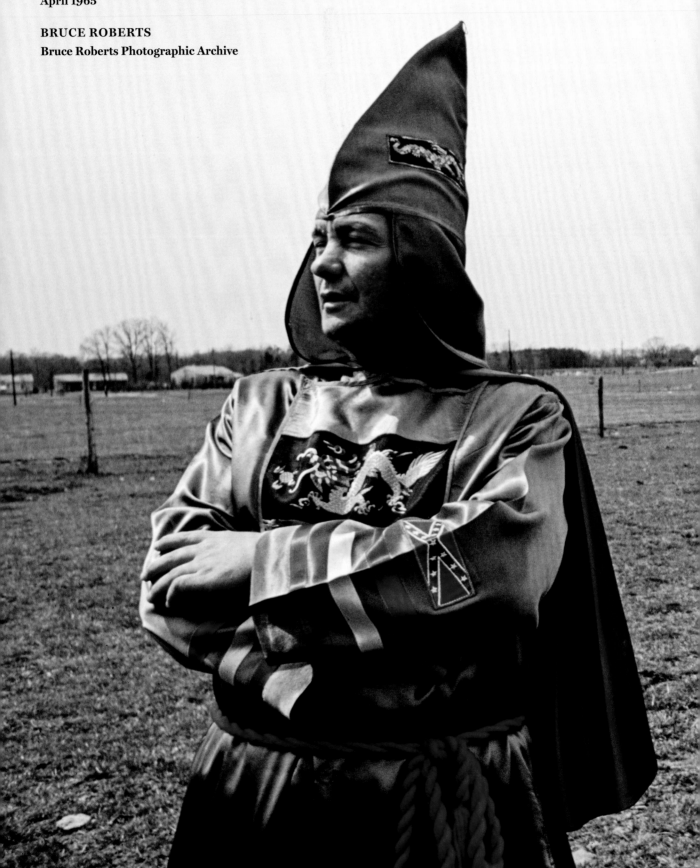

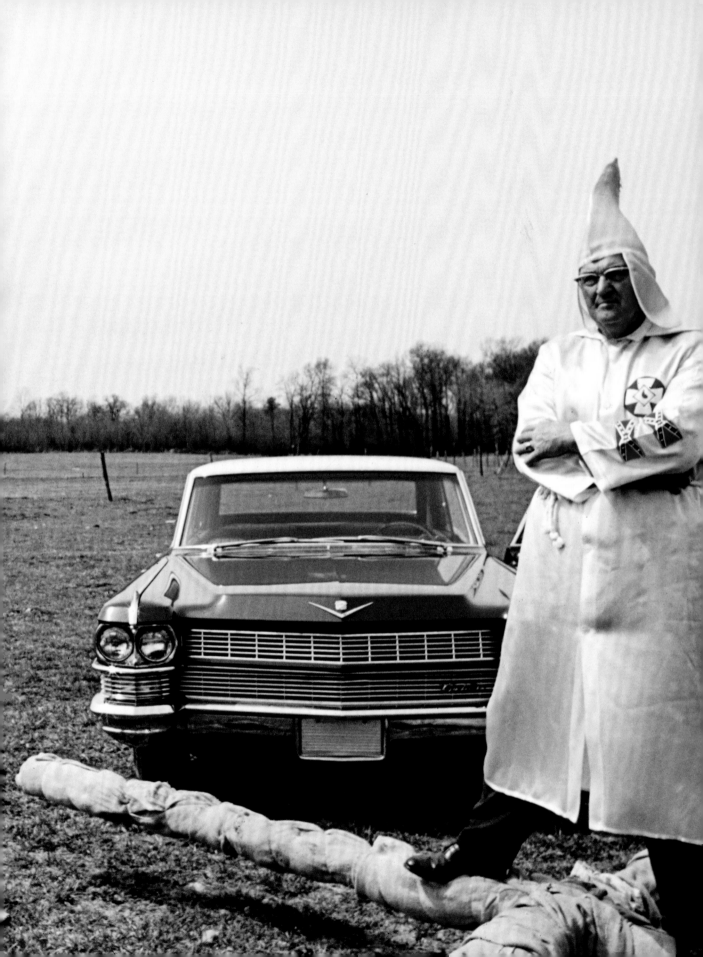

WITNESSES TO SELMA AND BIRMINGHAM

Violent clashes between law enforcement and peaceful protesters in Alabama were flashpoints in the civil rights movement. Photographers Spider Martin and Charles Moore, both Alabama natives, documented the brutal response of local officials to peaceful protests in Birmingham and Selma.

Martin, who worked for the *Birmingham News*, captured images of state troopers attacking marchers with clubs and tear gas on the Edmund Pettus Bridge in March 1965—an event that became known as "Bloody Sunday." Charles Moore, whose images were published in *Life* magazine, photographed the Birmingham protest in May 1963, where firehoses and dogs were turned on peaceful protesters.

The publication of their now-iconic photographs helped galvanize national support for the struggle and sway public opinion regarding the necessity for civil rights legislation. The archives of photojournalists based at the Briscoe Center include work prints, negatives, newspapers, and correspondence.

At age 27, Charles Moore was thrust into the battle for civil rights while working as a photographer for the *Montgomery Advertiser*. Always perilously close to the action, Moore came to view photography as his weapon in the struggle, saying that "I don't wanna fight with my fists, I wanna fight with my camera."

Contact prints from Charles Moore's 1963 photographs of protests in Birmingham, Alabama

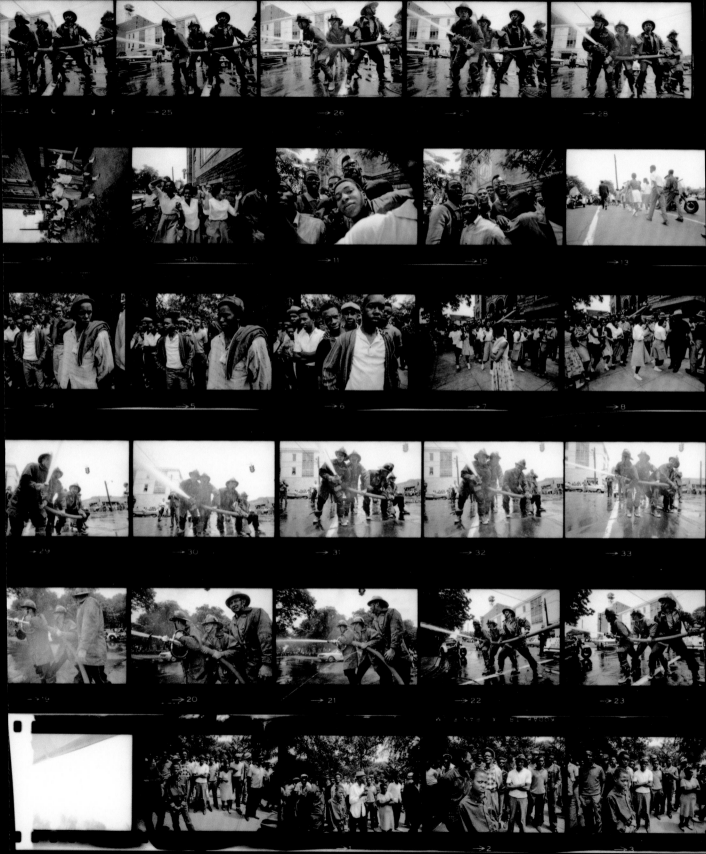

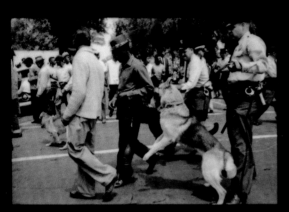
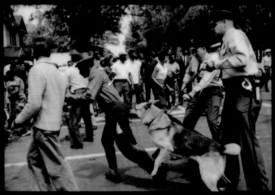

→ 33 → 34

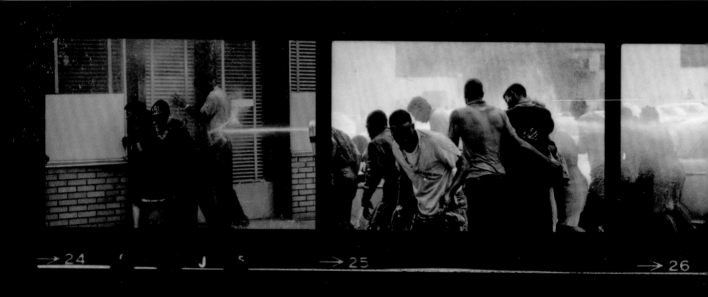

→ 24 → 25 → 26

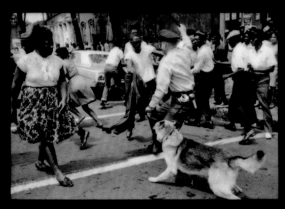
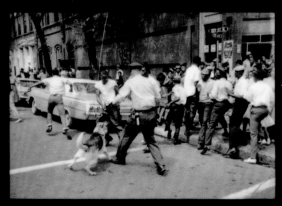

→ 36

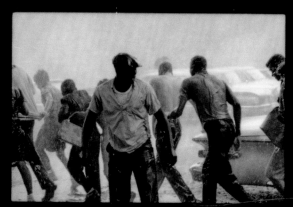
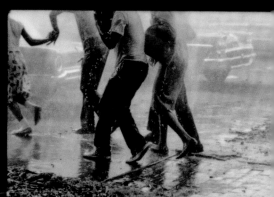

→ 27 → 28

In looking back on his work photographing the marches, Spider Martin wrote of his ability to "fit in when and where it was necessary. I had friends on both sides. Of course just stepping outside with a camera around my neck was enough to provoke a riot. It was like wearing a bull's eye. But then I would turn on the southern charm. Sometimes it helped."

Proof prints of Spider Martin's photographs of the Selma to Montgomery marches, March 1965. The center image shows Roy Wilkins, leader of the NAACP.

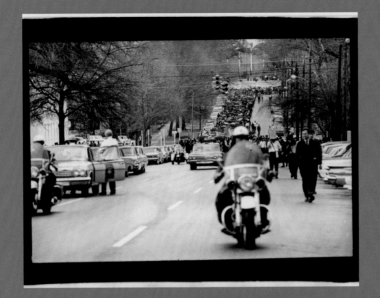

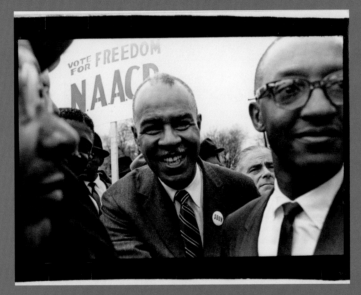

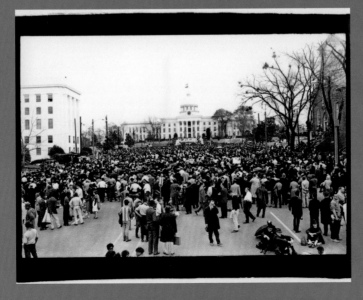

Print File
ARCHIVAL PRESERVERS
WWW.PRINTFILE.COM

DATE ASSIGNMENT

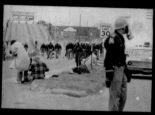
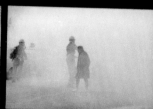

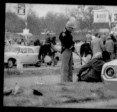

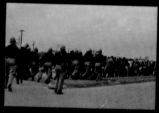
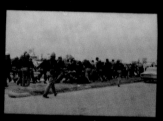
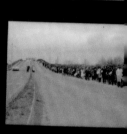

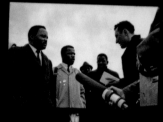
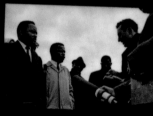
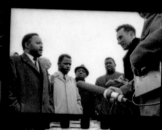
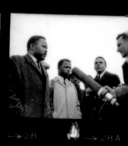

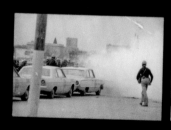
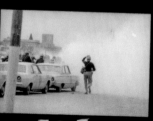

Organizers attempted the Voting Rights March from Selma to Montgomery three times: "Bloody Sunday," the attempt known as "Turnaround Tuesday" after marchers were halted at the Pettus Bridge, and the third march that reached Montgomery with federal protection along the route.

Representative John Lewis, one of the leaders of the Voting Rights March, later stated, "Dr. King said early on that there is no noise as powerful as the sound of the marching feet of a determined people, and I believed that."

Contact prints created from Spider Martin's photographs of "Bloody Sunday"

"A FIRE THAT WON'T GO OUT"

Regardless of the various differences between civil rights leaders and organizations, the vast majority saw their actions met with violence and intimidation. Civil disobedience, protest resistance, and self-defense involved putting one's body—and in some cases life—on the line.

Protesters in Birmingham and Selma were subjec to the water cannons, batons, and tear gas of local police forces. Malcolm X and Dr. Martin Luther King Jr. were assassinated in 1965 and 1968, respectively. Photojournalists also took personal risks to capture the mistreatment of civil rights protesters. Some became embedded in the struggle for justice. For others, documenting the movement was simply part of their work covering current events for local newspapers. Nonetheless, the images photojournalists produced provide a rich visual history of the risks that civil rights activists took in order to work for change.

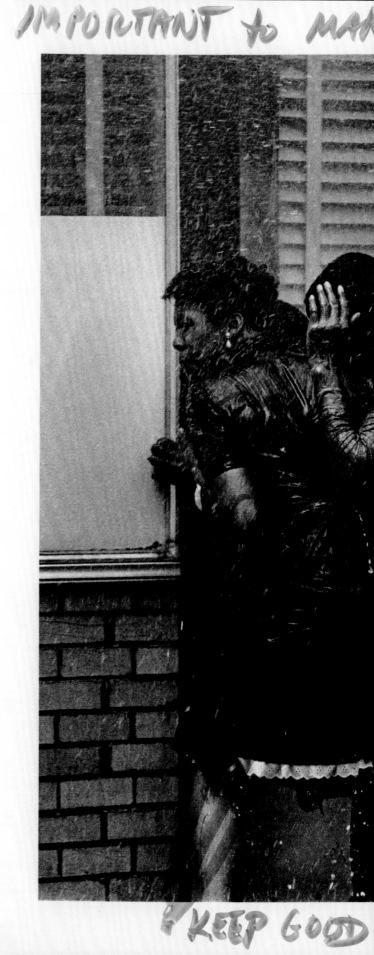

IMPORTANT to MA[

KEEP GOOD

This version of Charles Moore's photograph shows the photographer's printing specifications, demonstrating the power photographers had in manipulating the imagery of the civil rights era. The Birmingham attacks were especially horrifying to the American public; along with water hoses that were set to levels strong enough to peel bark off of trees, Bull Connor's police department attacked students with dogs. Moore said that his photographs would likely obliterate any notion of a "good southerner" in the national psyche.

High school students seek shelter as police aim high-pressure water hoses on them during a peaceful protest, Birmingham, Alabama, 1963

CHARLES L. MOORE
Charles L. Moore Photographic Archive

THIS A GUTSY PRINT THAT WILL STILL MAKE A GOOD COPY N86 —

DO NOT LET THIS GO GRAY or MUDDY

TAIL IN THIS AREA

Young man beaten for belonging to the NAACP, Dallas,
Texas, January 1951

R. C. HICKMAN
R. C. Hickman Photographic Archive

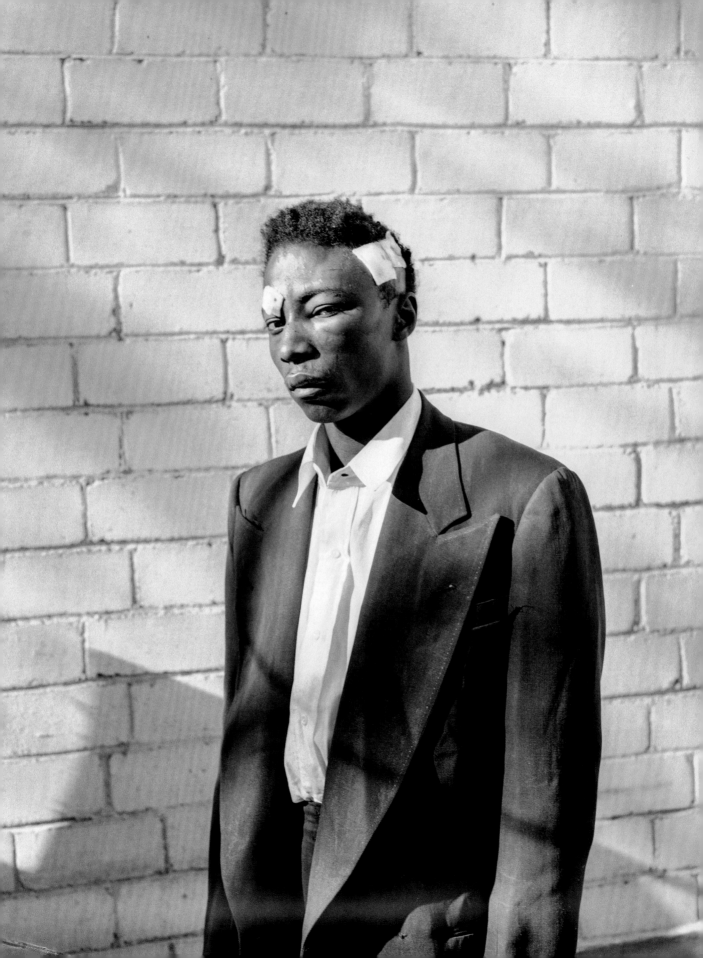

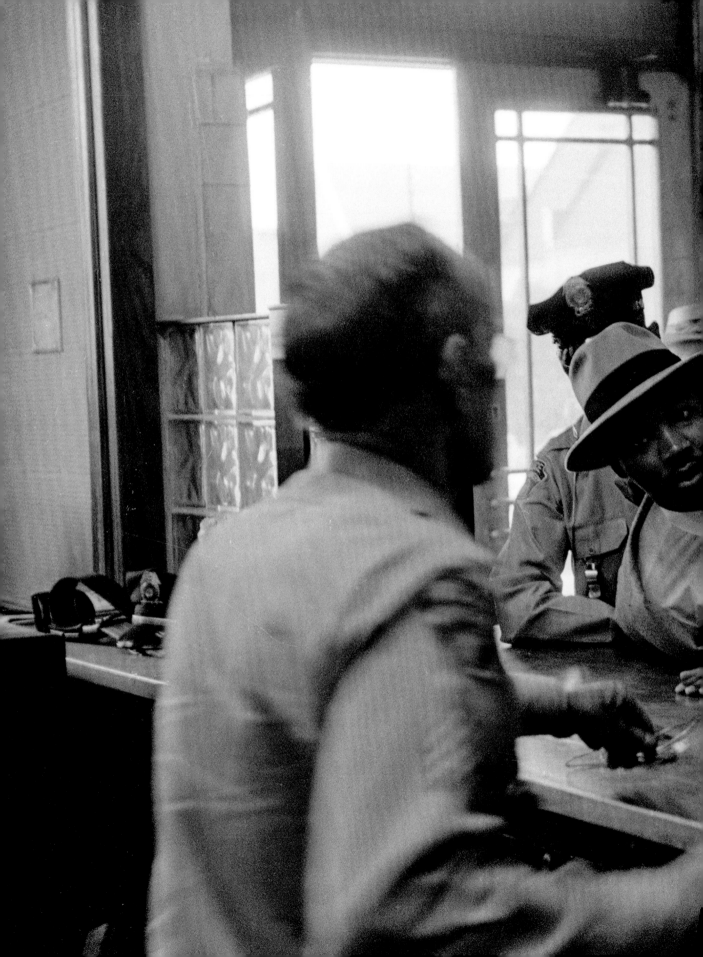

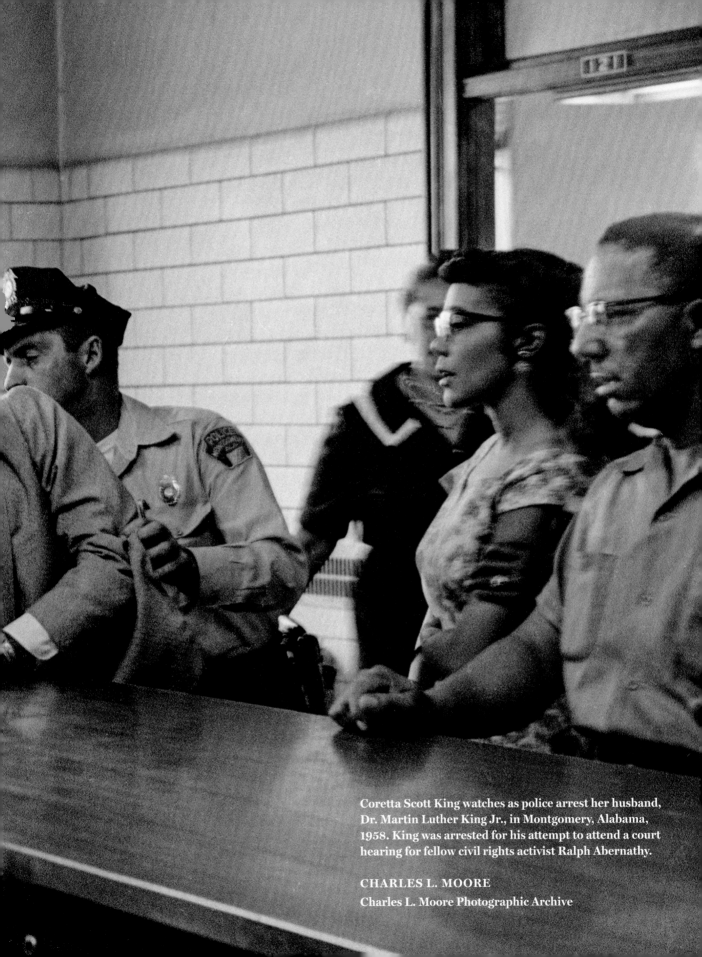

Coretta Scott King watches as police arrest her husband, Dr. Martin Luther King Jr., in Montgomery, Alabama, 1958. King was arrested for his attempt to attend a court hearing for fellow civil rights activist Ralph Abernathy.

CHARLES L. MOORE
Charles L. Moore Photographic Archive

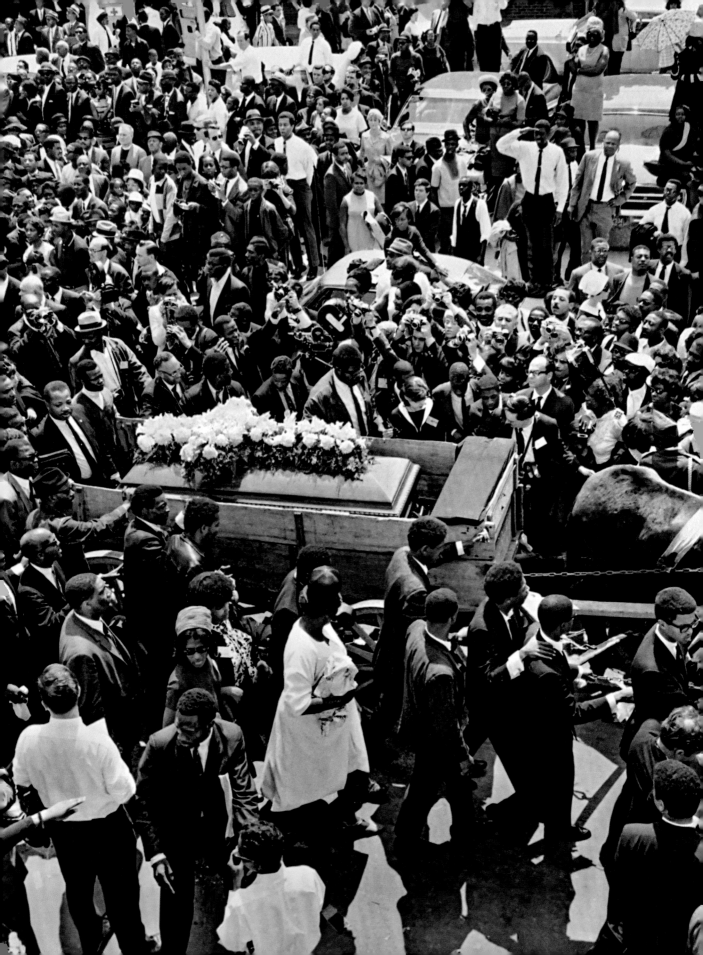

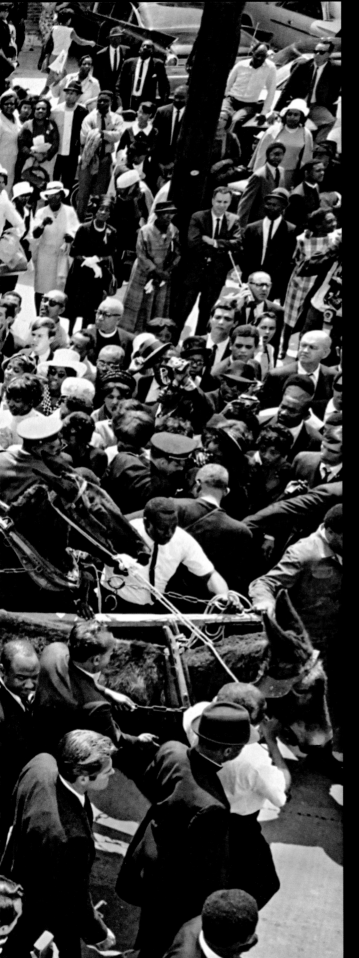

Funeral procession for Dr. Martin Luther King Jr. through the streets of Atlanta, Georgia, April 9, 1968

STEVE NORTHUP
Steve Northup Photographic Archive

OXFORD

When James Meredith arrived in Oxford to enroll at the University of Mississippi in 1962, he was followed to the city by lawmen from across the state. However, the sheriffs had not come to Oxford to support Meredith and the federal order to integrate; instead, they were there to support Lt. Governor Paul Johnson's opposition to Meredith's entry into the university and protest what they saw as federal interference in a local issue.

This photograph by Charles Moore, published in *Life* magazine immediately after Meredith's enrollment, was the subject of a 2003 book, *Sons of Mississippi,* by *Washington Post* reporter Paul Hendrickson that examined the later lives of the men shown in the photograph.

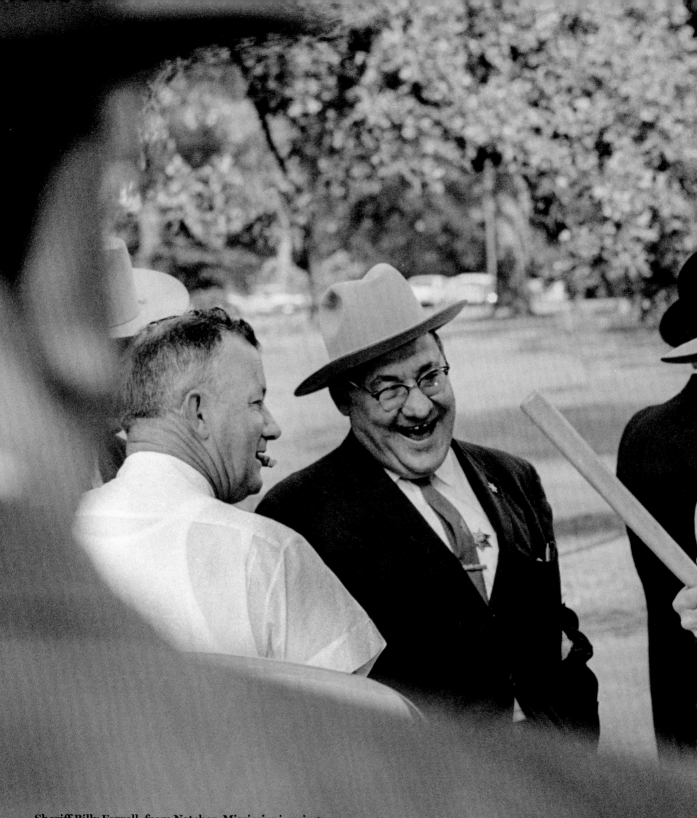

Sheriff Billy Ferrell, from Natchez, Mississippi, swings a
billy club as other Mississippi sheriffs look on, Oxford,
Mississippi, 1962

CHARLES L. MOORE
Charles L. Moore Photographic Archive

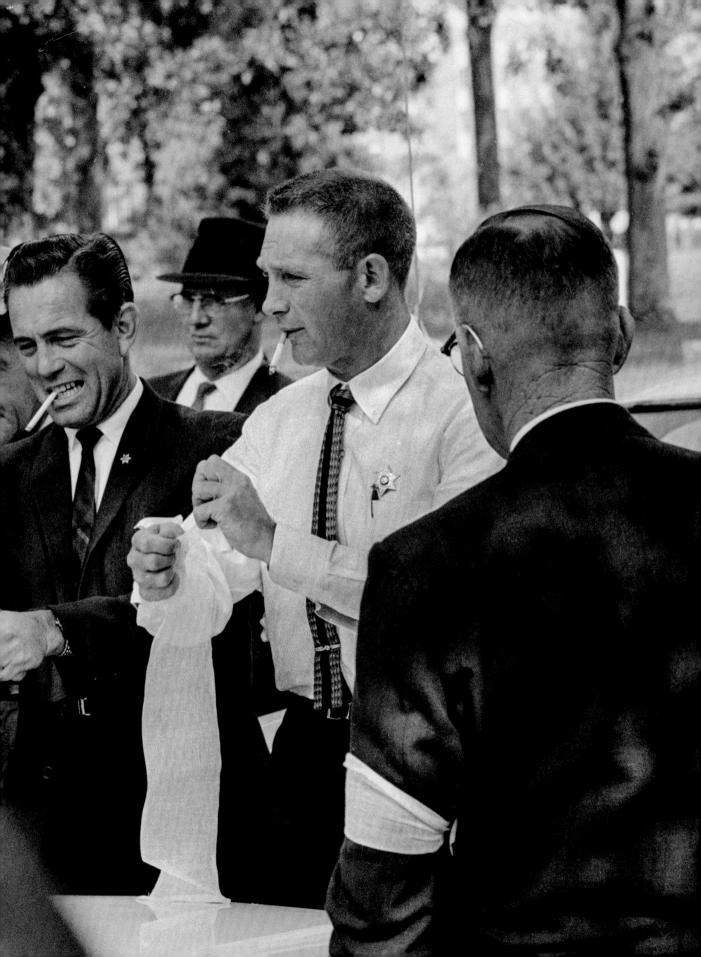

WALLACE

During the 1962 Alabama governor's race, George Wallace promised to strongly oppose integration if elected; during his swearing-in ceremony in early 1963, he vowed to support "segregation now, segregation tomorrow, segregation forever." After a federal district judge ordered the admittance of three African American students to the University of Alabama in 1963, Wallace protested their enrollment by blocking the door to the auditorium where the students were to pay their fees.

After a confrontation between Wallace and Deputy Attorney General Nicholas Katzenbach, President John F. Kennedy issued Executive Order 11111, which federalized the Alabama National Guard; through General Graham, Kennedy ordered Wallace to stand down and allow the students to access the building.

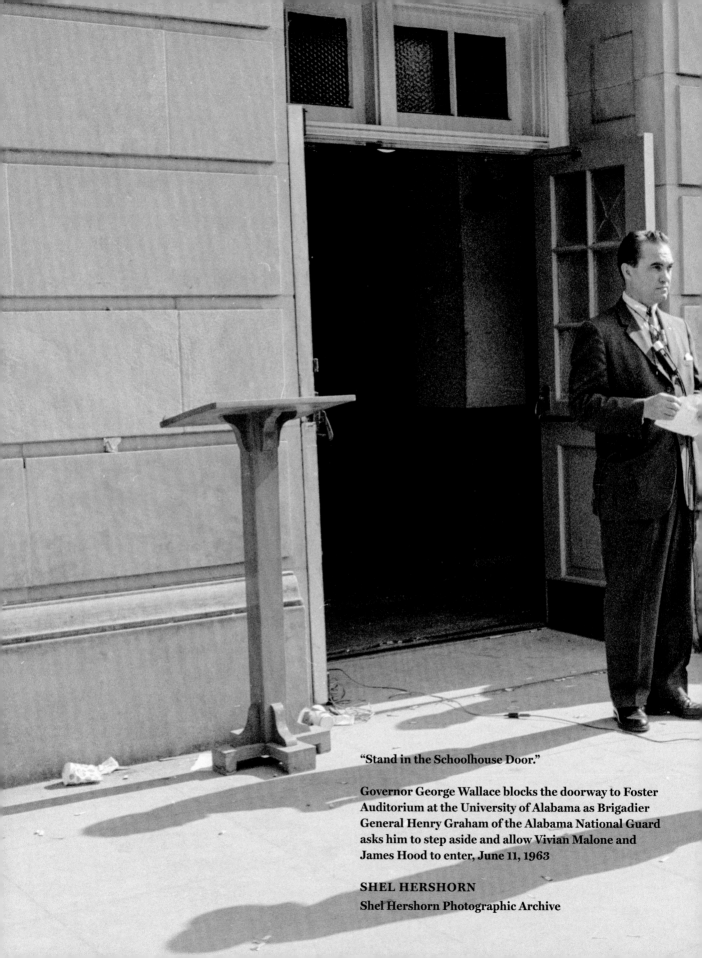

"Stand in the Schoolhouse Door."

Governor George Wallace blocks the doorway to Foster Auditorium at the University of Alabama as Brigadier General Henry Graham of the Alabama National Guard asks him to step aside and allow Vivian Malone and James Hood to enter, June 11, 1963

SHEL HERSHORN
Shel Hershorn Photographic Archive

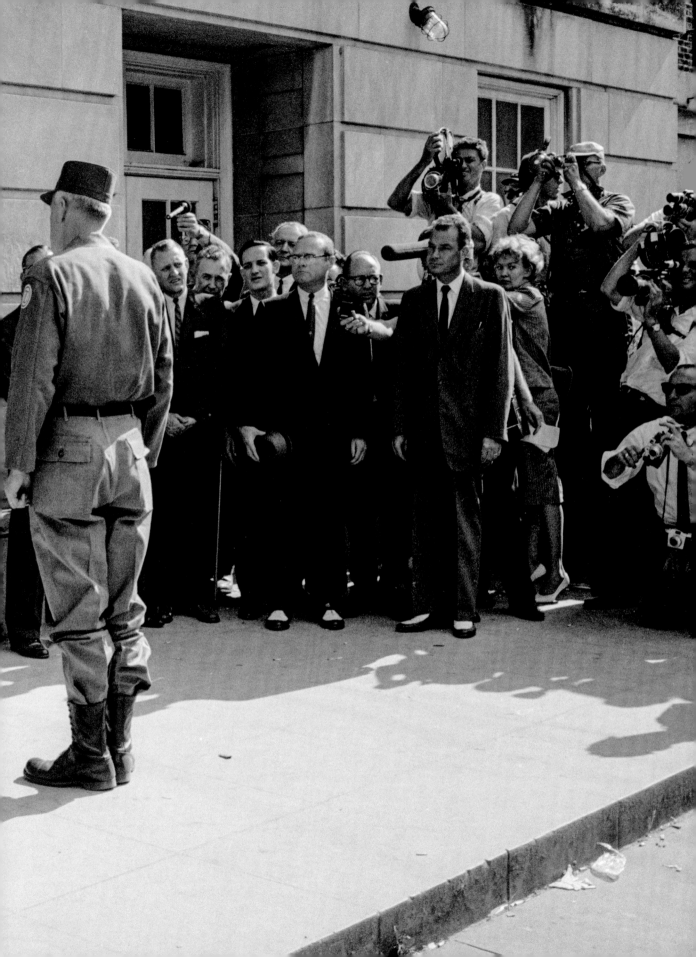

RIOTS 1968

Following the assassination of Dr. Martin Luther King Jr. on April 4, 1968, riots broke out in over a hundred American cities. After a night of chaos in Washington, D.C., the White House mobilized over 13,000 federal troops to quell violence in the city.

Over the following days, more than 1,000 buildings were damaged or destroyed and twelve individuals died, primarily from smoke inhalation. Due to the dangerous conditions, photographer Darryl Heikes was instructed not to work alone.

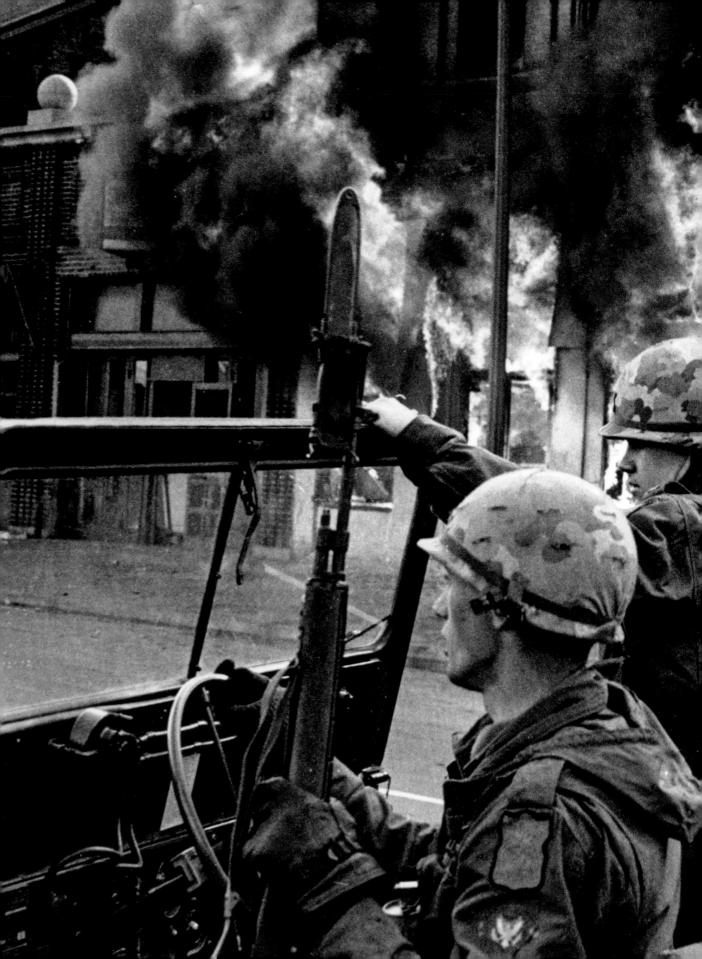

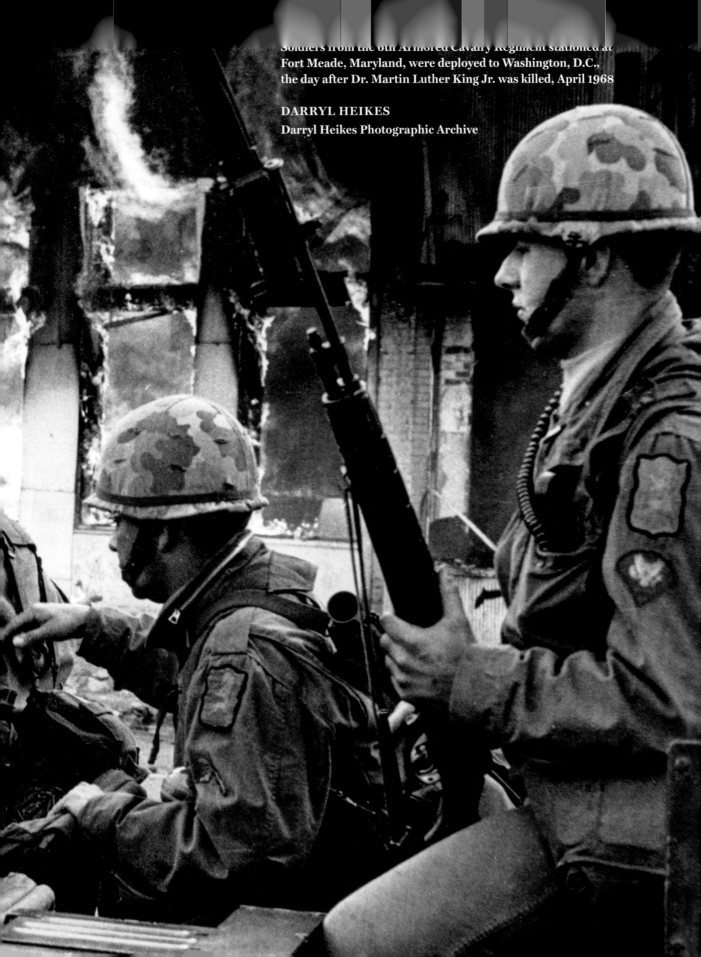

Soldiers from the 6th Armored Cavalry Regiment stationed at Fort Meade, Maryland, were deployed to Washington, D.C., the day after Dr. Martin Luther King Jr. was killed, April 1968

DARRYL HEIKES
Darryl Heikes Photographic Archive

JAMES MEREDITH

nspired by President John F. Kennedy's inauguration speech, Air Force veteran and Jackson State University student James Meredith began an application to transfer to the University of Mississippi in 1961. After being denied admission to the school twice, Meredith filed suit, claiming that the denial was based on his race, citing his successful academic and military service records. The courts agreed, and, after unsuccessful protests by the state's governor and lieutenant governor, Meredith enrolled at the school on October 1, 1962, graduating the following year.

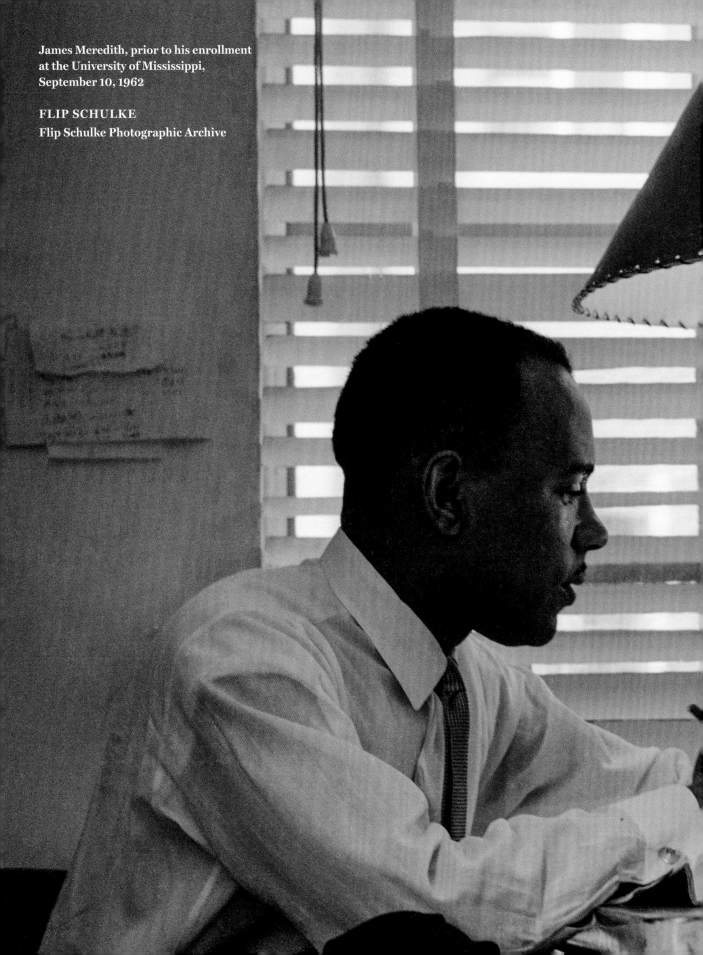

James Meredith, prior to his enrollment at the University of Mississippi, September 10, 1962

FLIP SCHULKE
Flip Schulke Photographic Archive

Meredith began a solo march to protest continuing racial disparities in early June 1966. On the second day, the march came to a temporary halt after a white sniper, James Avery Norvell, shot Meredith. A groundswell of thousands of civil rights activists came to Mississippi to continue in Meredith's place.

Mississippi state troopers use tear gas to disperse marchers at the Meredith March Against Fear, Canton, Mississippi, June 23, 1966. Town officials had forbidden marchers from camping overnight in the small town.

CHARLES KELLY
Eddie Adams Photographic Archive

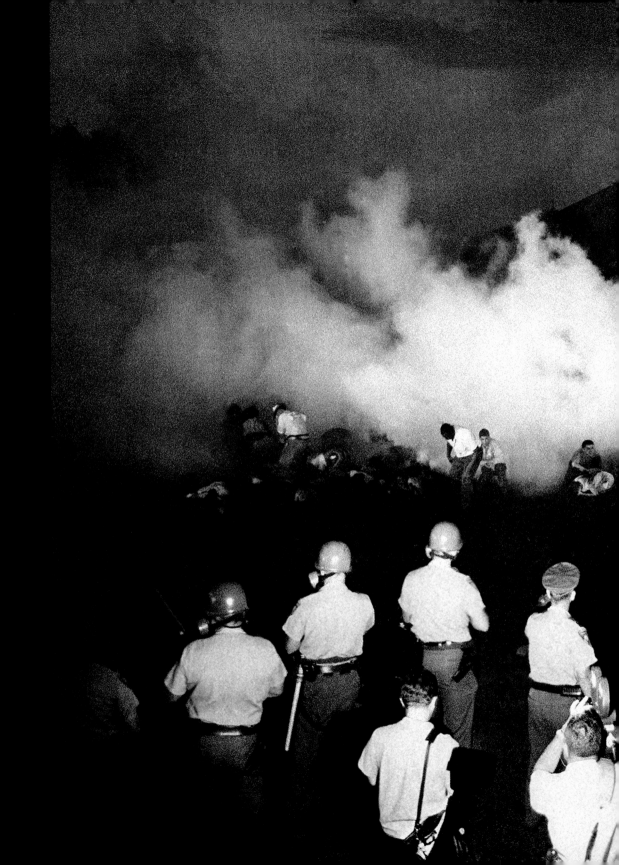

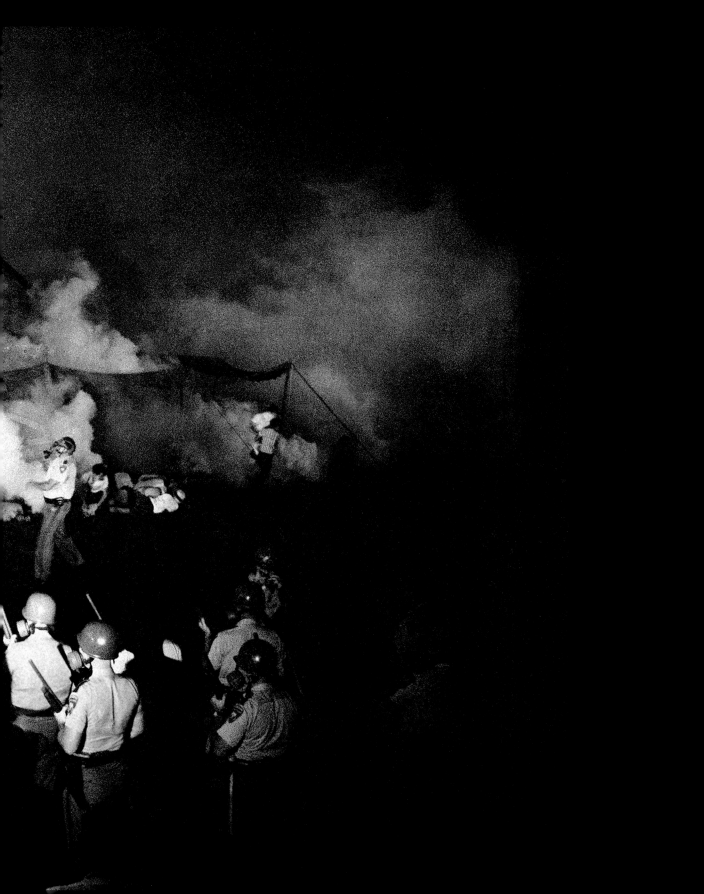

MEDGAR EVERS

Civil rights activist Medgar Evers was murdered in June 1963 as he arrived home in Jackson, Mississippi. In the early 1960s, Evers became well known throughout the state for his investigation into the death of Emmett Till and his work as Mississippi's first NAACP field secretary. Two trials of Evers's suspected assassin, Byron de la Beckwith, ended in hung juries, but Beckwith was finally convicted of the murder in 1994 when new evidence came to light.

A shattered windowpane at the home of Medgar Evers, broken during the assassination of the civil rights leader, 1963

FLIP SCHULKE
Flip Schulke Photographic Archive

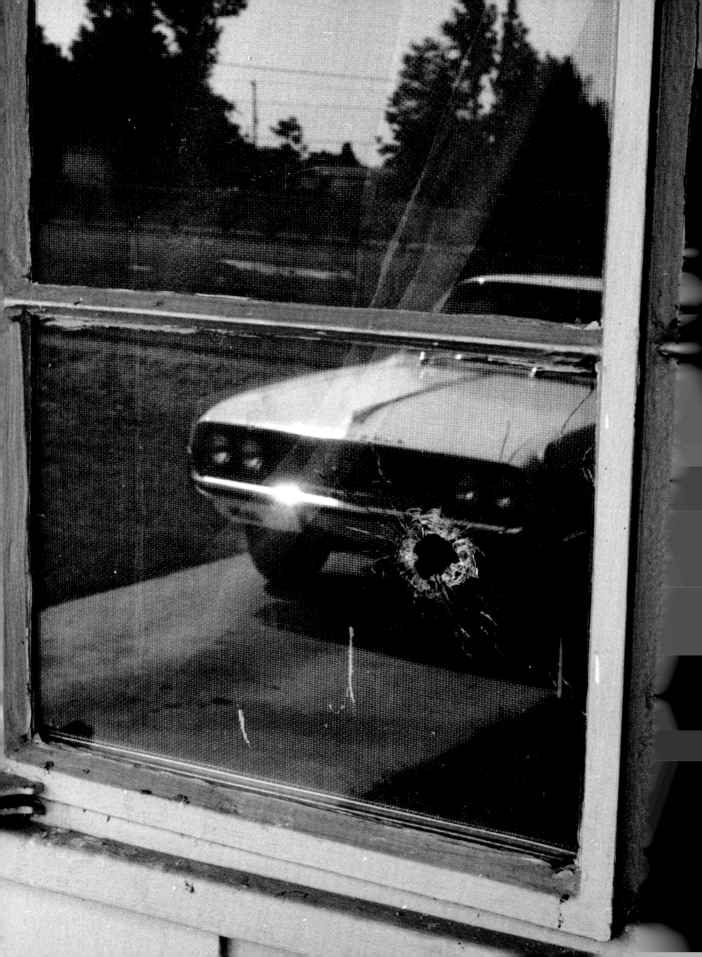

FREEDOM MANIFESTED

I n 1954, the Supreme Court's *Brown v. Board of Education* ruling prohibited segregation in public schools: "Separate educational facilities are inherently unequal," wrote Chief Justice Earl Warren. This landmark case, along with the Civil Rights Act of 1964 and Voting Rights Act of 1965, dismantled the legal and legislative framework upon which the Jim Crow era had been founded. Schools and colleges began to integrate, black Americans were able to have a voice in elections, and—slowly—American culture began to change.

But for many black Americans, the struggle had only just begun. Rights groups continue to advocate for the advance of justice and equality today. Much of the legacy of the civil rights movement would be lost to the past but for the collection and preservation of historical evidence. The center's civil rights and social justice collections complement its photojournalism holdings, giving researchers a vast array of rich resources for understanding this struggle for justice, from Jim Crow to Black Power and beyond.

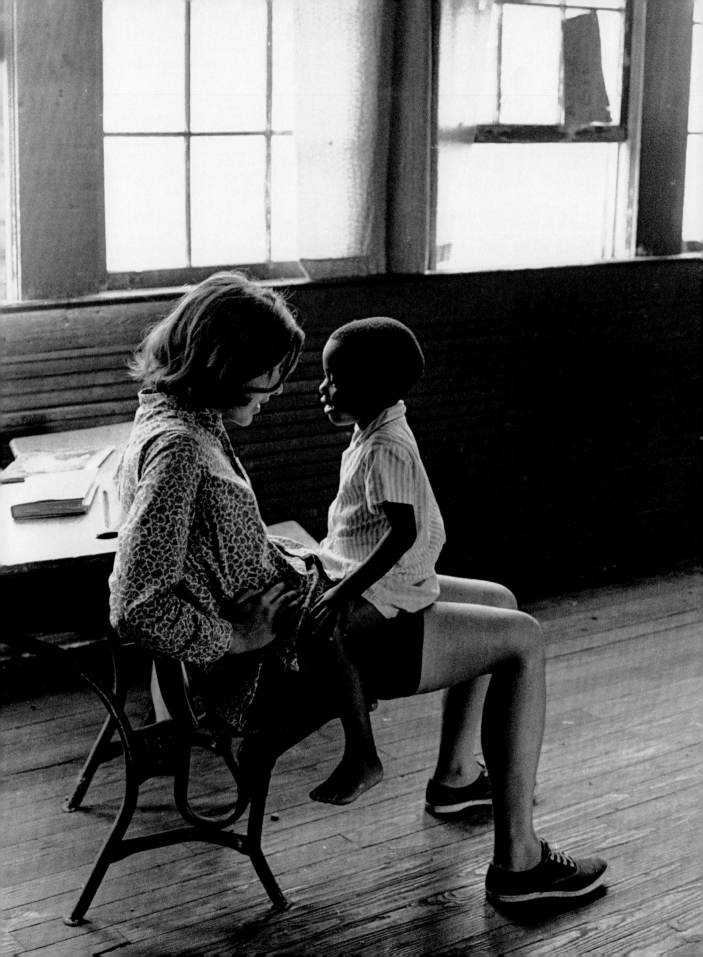

VISTA (Volunteers in Service to America) began during Lyndon B. Johnson's presidency as one of the administration's Great Society anti-poverty initiatives. The national service program, a domestic version of the Peace Corps, currently operates under the name AmeriCorps VISTA.

Suzy, a VISTA volunteer working in rural North Carolina, speaks with an unidentified child, 1964

BRUCE ROBERTS
Bruce Roberts Photographic Archive

Charlotte schools were the subject of a landmark Supreme Court case, *Swann v. Charlotte-Mecklenburg*, which upheld the constitutionality of busing students to schools outside their neighborhoods to promote diversity.

Students board a bus at Beverly Woods School in Charlotte, North Carolina, circa 1970

BRUCE ROBERTS
Bruce Roberts Photographic Archive

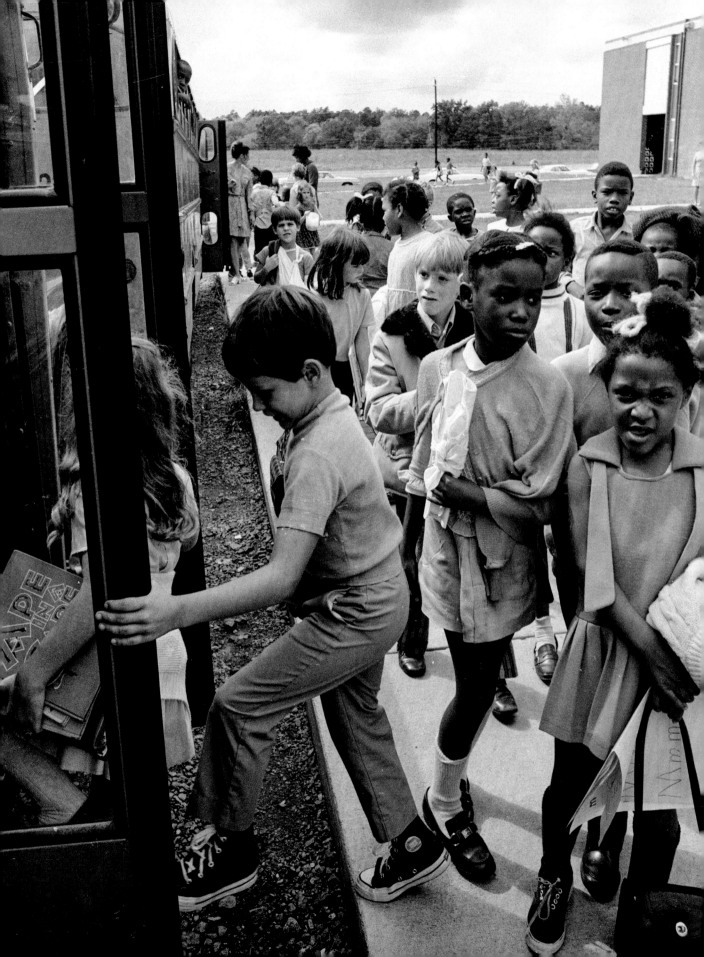

University of Alabama as Brigadier General Henry Graham
of the Alabama National Guard asks him to step aside and
allow Vivian Malone and James Hood to enter, June 11, 1963
SHEL HERSHORN
Shel Hershorn Photographic Archive

130-131 Soldiers from the 6th Armored Cavalry Regiment
stationed at Fort Meade, Maryland, were deployed to
Washington, D.C., the day after Dr. Martin Luther King Jr.
was killed, April 1968
DARRYL HEIKES
Darryl Heikes Photographic Archive

134-135 James Meredith, prior to his enrollment at the
University of Mississippi, September 10, 1962
©FLIP SCHULKE
Flip Schulke Photographic Archive

138-139 Mississippi state troopers use tear gas to disperse
marchers at the Meredith March Against Fear, Canton,
Mississippi, June 23, 1966. Town officials had forbidden
marchers from camping overnight in the small town.
CHARLES KELLY
Eddie Adams Photographic Archive
AP Image/used with permission

141 A shattered windowpane at the home of Medgar Evers,
broken during the assassination of the civil rights leader,
1963
©FLIP SCHULKE
Flip Schulke Photographic Archive

144 Suzy, a VISTA volunteer working in rural North Caro-
lina, speaks with an unidentified child, 1964
BRUCE ROBERTS
Bruce Roberts Photographic Archive

147 Students board a bus at Beverly Woods School in
Charlotte, North Carolina, circa 1970
BRUCE ROBERTS
Bruce Roberts Photographic Archive

EDDIE ADAMS (1933-2004)

The Eddie Adams Photographic Archive spans the photographer's entire career. Adams is well known for his influential coverage of the Vietnam War. In addition to war-related photography, the archive includes a diverse range of subject matter including poverty in America, antiwar demonstrations, and inner-city riots, as well as the photographer's intimate portraits of high-profile figures.

ROY WILKINSON ALDRICH (1869-1955)

At the time of his retirement in 1947, Roy Wilkinson Aldrich had the longest tenure of any Texas Ranger, thirty-two years. An ardent collector of Texas history, botany, and natural history, most of Aldrich's archive reflects his interests outside law enforcement, with the remaining papers documenting Aldrich's long career with the Texas Rangers.

DENNIS BRACK (BORN 1939)

Since he began working as a photojournalist in 1963, Dennis Brack has covered countless major news stories including eleven presidential administrations, world leaders and U.S. politicians, and the civil rights movement. After earning a law degree, Brack joined Black Star Publishing Company and published photographs in the *Washington Post*, *Life*, *Time*, and *Newsweek* before working as a *Time* contract photographer.

JOHN DOMINIS (1921-2013)

During his twenty years at *Life* magazine, John Dominis covered not only sports, but also food, travel, lifestyle, wildlife, cultural events, politics, and celebrities, including Muhammad Ali, Steve McQueen, and Frank Sinatra. In 1975, he became picture editor at *People* magazine and served in that capacity as well at *Sports Illustrated* from 1978 until 1982.

BOB GOMEL (BORN 1933)

As a *Life* photographer from 1959 to 1969, Robert "Bob" Gomel created iconic imagery that helped to define the 1960s, including photographs of John F. Kennedy's funeral, the 1963 March on Washington, Muhammad Ali (then Cassius Clay), Marilyn Monroe, and the Beatles. Later in his career, Gomel moved into commercial photography and shot advertising campaigns.

DARRYL HEIKES (BORN 1938)

Darryl Heikes began his career at his high school newspaper. While a student at Kansas State University, Heikes was a stringer for United Press International (UPI) and the Associated Press, among others. From 1961 to 1981 he worked as a staff photographer at multiple UPI bureaus. In 1981, Heikes began covering the White House for *U.S. News & World Report*, documenting international affairs and multiple presidential campaigns.

SHEL HERSHORN (1929-2011)

Shel Hershorn learned photography while serving in the U.S. Navy. Hershorn was based in Dallas for most of his career; consequently, a significant portion of his collection documents Texas subjects ranging from industry to fashion

to sports to politics. However, Hershorn occasionally traveled to cover current events, including the civil rights movement during the early 1960s.

R. C. HICKMAN (1918-2007)
Born in the East Texas town of Mineola, R. C. Hickman honed his craft as a photographer during his service in the U.S. Army during World War II. After the war, Hickman worked as a photographer for the *Dallas Star Post* and as a freelancer for *Jet*, while also documenting inequalities in public facilities to support NAACP legal cases.

CHARLES KELLY (1932-2016)
Charles Kelly worked for thirty-three years as a photographer with the Associated Press, covering a wide variety of assignments for the agency including the civil rights movement, sports, celebrities, and politics during tenures at the Memphis, Milwaukee, and Atlanta photo bureaus. He retired in 1993.

CALVIN LITTLEJOHN (1909-1993)
Photographer Calvin Littlejohn established a commercial photography studio in Fort Worth in 1934, continuing his practice for nearly six decades. Littlejohn's archive provides a comprehensive portrait of the African American experience in Fort Worth and Tarrant County during the era of segregation and beyond.

JAMES "SPIDER" MARTIN (1939-2003)
Alabama photojournalist Spider Martin's career began with a commission from U.S. Steel; Martin then worked as a freelance photojournalist for the *Birmingham News*. At the newspaper, Martin documented key events in the civil rights movement, including the events on Bloody Sunday in Selma on March 7, 1965, and the Selma to Montgomery march later the same month.

CHARLES L. MOORE (1931-2010)
Charles Moore trained as a combat photographer in the U.S. Marines, then joined the staff of the *Montgomery Advertiser* in 1957. While working for the paper, he photographed the 1958 arrest of Martin Luther King Jr., the first of many Moore images to be published in *Life* magazine. Moore left the *Advertiser* in 1962 for a freelance career.

STEVE NORTHUP (BORN 1941)
Steve Northup's photographic career began in 1962 when he joined United Press International (UPI) in San Francisco

and continued to work with them in Miami and Saigon. He covered the Vietnam War in 1965 and 1966. He then joined the *Washington Post* for five years before moving to *Time* magazine, where he was on staff for twenty years.

BRUCE ROBERTS (BORN 1930)
Bruce Roberts began his career in journalism as a reporter for the *Tampa Tribune* and went on to serve as editor and publisher of the *Lumberton Post* and the *Scottish Chief*, as a staff photographer for the *Charlotte Observer*, and as director of photography for the *Wilmington News Journal*. Roberts's work chronicles the Southern experience from the early civil rights years to social programs such as Head Start, VISTA, and various rural health initiatives.

FLIP SCHULKE (1930-2008)
Flip Schulke was one of America's premier photojournalists for more than forty years. Through his close friendship with Dr. Martin Luther King Jr., Schulke became known as one of the leading chroniclers of the civil rights movement. He covered nearly every major civil rights story in the South from the 1950s until King's assassination in 1968.

STEPHEN SHAMES (BORN 1947)
Photojournalist Stephen Shames has documented social issues with his camera for over fifty years. After photographing welfare programs instituted by the Black Panther Party at the beginning of his career, Shames went on to capture images of child labor, poverty, the Bronx, and AIDS orphans.

STAN WAYMAN (1927-1973)
Stanley Edmond Wayman joined the *Miami Herald* in 1950 and began freelancing in 1955. He moved to *Life* magazine in 1957, where he worked at the Chicago bureau. Subsequent postings to New York, Bonn, and Paris culminated in his becoming Moscow bureau chief in 1962. In 1964, he moved to the Washington, D.C., bureau.

ICONS OF AMERICAN PHOTOGRAPHY
A recent addition to the Briscoe Center's photojournalism archives, the Icons of American Photography Collection consists of outstanding photographs that depict significant moments in U.S. history. This book features a number of photographs from the Icons collection, including the work of Carl Iwasaki and Paul Schutzer.

THE FOLLOWING BRISCOE CENTER COLLECTIONS ARE REPRESENTED IN THIS VOLUME:

ACKNOWLEDGMENTS

Adams (Eddie) Photographic Archive
Aldrich (Roy Wilkinson) Papers
Brack (Dennis) Photographic Archive
Dominis (John) Photographic Archive
Gomel (Bob) Photographic Archive
Heikes (Darryl) Photographs
Hershorn (Shel) Photographic Archive
Hickman (R. C.) Photographic Archive
Icons of American Photography Collection
Littlejohn (Calvin) Photographic Archive
Martin (James "Spider") Photographic Archive
Moore (Charles L.) Photographic Archive
Northup (Steve) Photographic Archive
Roberts (Bruce) Photographic Archive
Schulke (Flip) Photographic Archive
Shames (Stephen) Photographic Archive
Wayman (Stan) Photographic Archive
Almetris Duren Papers
James Leonard, Jr., and Lula Peterson
 Farmer Papers
Sam Rayburn Papers

An exhibit and a book are team efforts that draw on the knowledge and expertise of multiple people. Thanks to the Briscoe Center curatorial team, Dr. Sarah Sonner, Alison Beck, Lynn Bell, Amy Bowman, and Ben Wright, and to Hal Richardson and Dr. Holly Z. Taylor for their work with the exhibit production. We also appreciate our interns: Laurel Day, Kathleen Forrest, and Brooke Johnson. Thanks also to Kirk Anders and Jeremy Burks and their team at Austin Art Services for their exhibit design and installation support and to Derek George for his design of the exhibit catalog.

We are grateful to the photographers whose work is featured in this book and also appreciate the efforts of the following heirs and estate executors: Ron Abram, Alyssa Adams, Dori Dominis Beer, Dell Heikes, Tad Hershorn, Tracy Martin, Royetta Tuck-Potts, Michelle Peel-Vorse, Donna Schulke, and Gary Truman.

The exhibit *Struggle for Justice: Four Decades of Civil Rights Photography* was sponsored in part by the generosity of Alec Rhodes and Jane Hilfer.

We are delighted to see the material from our exhibit continue to inform readers in the pages of this book. Thanks to Dave Hamrick and Cassandra Cisneros at the University of Texas Press, and thanks to Alison Beck, Holly Taylor, and Amy Bowman at the Briscoe Center.

Compilation and introduction copyright © 2020 by the Dolph
Briscoe Center for American History
All rights reserved
Printed in China
First edition, 2020

Requests for permission to reproduce material from this work
should be sent to:

 Permissions
 University of Texas Press
 P.O. Box 7819
 Austin, TX 78713-7819
 utpress.utexas.edu/rp-form

∞ The paper used in this book meets the minimum requirements
of ANSI/NISO Z39.48-1992 (R1997) (Permanence of Paper).

Library of Congress Cataloging-in-Publication Data

Names: Carleton, Don, author.
Title: Struggle for justice : four decades of civil rights photography /
 preface by Don Carleton.
Description: Austin : University of Texas Press, 2019.
Identifiers: LCCN 2019052160
 ISBN 978-1-4773-2114-0 (cloth)
Subjects: LCSH: Civil rights demonstrations—United States—
 History—20th century—Photographs—Exhibitions. | African
 Americans—Political activity—United States—History—20th
 century—Photographs—Exhibitions. | African Americans—
 Civil rights—United States—History—20th century—
 Photographs—Exhibitions. | Photojournalists—United
 States—History—20th century—Exhibitions. | Dolph Briscoe
 Center for American History—Photograph collections—
 Exhibitions. | LCGFT: Documentary photographs.
Classification: LCC E185.61 .C266 2019 | DDC
 323.1196/0730222—dc23
LC record available at https://lccn.loc.gov/2019052160

Front cover:
**Women sing freedom songs during the Selma to
Montgomery march, March 1965**
CHARLES L. MOORE
Charles L. Moore Photographic Archive